IN AND AROUND
ROTHERHAM

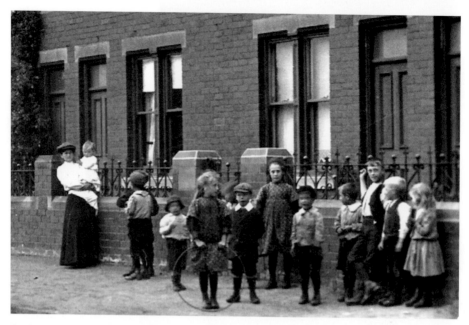

Station Row, Laughton Common. On Rotherhamunofficial.co.uk it is stated: 'Laughton Common has no ancient history but it is likely to have been the common land for the villagers of Laughton ... Many of Laughton Common's houses are early and mid 20th century workers' houses built for the miners at nearby pits such as Dinnington and Thurcroft.'

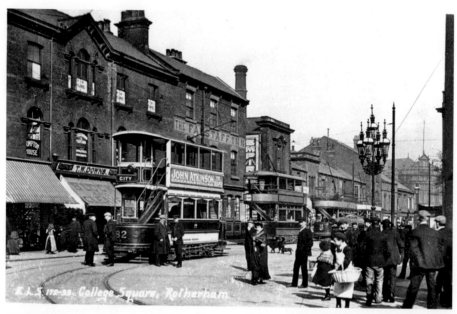

College Square, Rotherham, where a number of trams may be seen. The Rotherham Tramway service began on 31 January 1903 and ended on 13 November 1949. Rotherham trams ran on six lines joining in the town's centre and served Thrybergh, Silverwood Colliery and Broom Road to the east, Canklow and Sheffield to the south, Kimberworth to the west and Rawmarsh to the north.

IN AND AROUND ROTHERHAM

From the Scrivens Collection

PETER TUFFREY

AMBERLEY

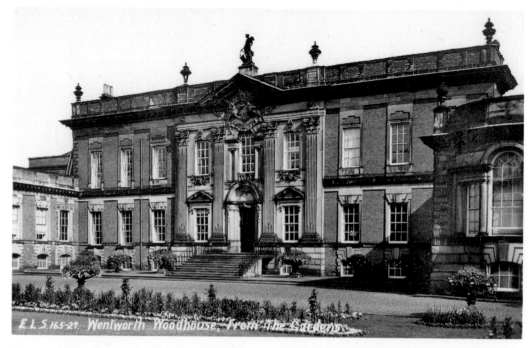

Wentworth Woodhouse, seen here from the gardens, is a Grade I listed country house near the village of Wentworth, Rotherham. Its east front, 606 feet (185 m) long, is the longest country house façade in Europe. The house includes 365 rooms and covers an area of over 2.5 acres (10,000 m2). Built by Thomas Watson-Wentworth, 1st Marquess of Rockingham (1693–1750), and added to by his heir. In the nineteenth century it became the inherited family seat of the Earls Fitzwilliam.

This book is dedicated to the late Geoff Thomas.

First published 2010

Amberley Publishing Plc
Cirencester Road, Chalford,
Stroud, Gloucestershire, GL6 8PE

www.amberleybooks.com

Copyright © Peter Tuffrey 2010

The right of Peter Tuffrey to be identified as the Author of this work has been asserted in accordance with the Copyrights, Designs and Patents Act 1988.

ISBN 978-1-4456-0120-5

British Library Cataloguing in Publication Data.
A catalogue record for this book is available from the British Library.

Typesetting and Origination by FONTHILLDESIGN.
Printed in Great Britain.

Contents

Acknowledgements

I would like to thank the following people for their help: Paul Fox, Tony Munford and his staff in the Local Studies and Archives Section at Rotherham Library, Geoff Thomas, Tristram Tuffrey and all the people at Wikipedia. Gratitude should also be expressed to Rotherham Libraries for allowing a number of their pictures to be reproduced here.

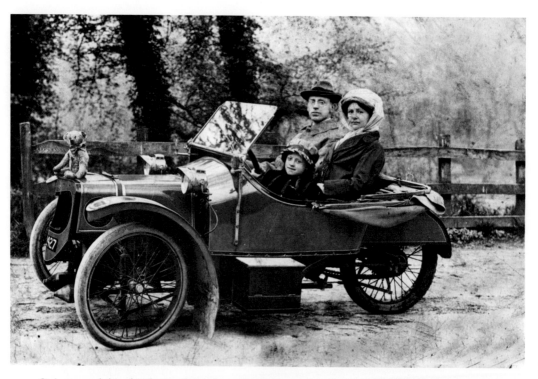

Scrivens and his family in their three-wheeled vehicle, that is sometimes featured in his photographs.

Introduction

In 1996, I produced a book of Edgar Leonard Scrivens' photographs of Doncaster. Now I am pleased to offer another one – *In and Around Rotherham* – and who knows, in the future there may be more volumes, illustrating other areas that he covered.

During the autumn of 1985, I travelled south to meet Scrivens' only surviving daughter, Ivy. She told me that her father was born in 1883 and first became interested in photography when he was at school, obtaining his first camera while still a pupil. In time he worked as a press photographer, establishing a photographic business in Cooper Street, Doncaster, during the first decade of the twentieth century. Other companies in Doncaster at this time included Don Lion, Arjay Productions, Empire Views, Regina Company Press, and J. Simonton & Son. All these companies produced picture postcards, but Scrivens was to become the leading exponent of this trade, not only in his own town but arguably throughout South Yorkshire, North Derbyshire and North Nottinghamshire. This is because, for the next thirty years, he captured on his postcards almost every main road, street or thoroughfare in nearly every town and village within a forty-mile radius of Doncaster. He also took pictures in Whitby, Scunthorpe and York.

All Scrivens' postcards bear his unmistakeable initials, E. L. S., and he evolved a meticulous numbering system for his cards. On a card numbered 172-27, the first number denotes the locality, in this case number 172 relates to Rotherham. The second number indicates that the postcard is the 27th in the Rotherham series. Scrivens photographed over 250 localities, with a fair number of cards in each series.

Over the years, Scrivens' postcards have grown in popularity, reflected in the prices paid for them by dealers and collectors. His pictures show scenes prior to industrial, commercial, and roadway developments, and this is what makes the pictures in this book particularly interesting. In his views of Bridgegate, Rotherham, we see the thoroughfare before and after widening. We see Anston and Wickersley before the advent of the motor car and subsequent roadway developments. He has also not only photographed the former rural splendour of some villages, but recorded their evolution into sprawling mining communities, which is unique in an area like Rotherham. We see this evolution in the views of Dinnington and Maltby.

Scrivens' postcard views have outstanding clarity, are beautifully composed, and full of incidental detail and curious features. An example of the latter is evident in

the view of Market Place, Rotherham, where the Tramway's Department's track cleaner is visible. Additionally, he always seems to have been able to persuade an army of children to pose in his views, adding charm and interest to the scene.

During the 1920s and 1930s, Scrivens re-photographed a number of locations, already recorded earlier in his career, adding the letter 'G' or 'V', depending on the period, to the numbering on the cards. We see this practice clearly in the views of the Bridge Inn and College Street, Rotherham.

By the 1920s, Scrivens had moved his photographic business to Queen's Road, Doncaster, while living with his wife and two daughters in Craithie Road, Doncaster. At this time, his postcard and developing/printing business flourished. His postcard views were sold in a variety of outlets including post offices, newsagents and stationers. Scrivens' daughter Ivy remembers that the Queen's Road premises were methodically organised to accommodate the various photographic processes, with up to twenty-five people being employed to cope with the workload. She also recalls that her father rarely brooded on matters and often arrived home in the evenings whistling 'Tip-toe Through the Tulips'. He had virtually no other interests apart from photography and frequently lectured on the subject to local camera clubs and other photographic societies.

When Scrivens died in 1950 and his business was sold, no one bothered to save the thousands of postcard view negatives neatly filed in pigeon holes in an upstairs room at Queen's Road. Nobody appreciated their worth or could ever have envisaged that Scrivens would come to be known as one of the region's major topographical artists. At one time, there was a strong local rumour that a subsequent owner of the Queen's Road premises dumped the glass plate negatives in a hole on the site and covered them with concrete. However, having contacted the person who was said to have done this myself, the allegation was strenuously denied!

ONE

Rotherham: The Villages

The church of St James at Anston is an ancient building of stone erected about 1150, but chiefly in the Early English style. The reredos, erected in 1900, was a memorial to Mrs Roberts, relict of the late Samuel Roberts of Sheffield, a generous benefactor to the church. An organ was provided in 1899. The nave and chancel were restored in 1886 and the aisles and porch in 1890. There were 300 sittings. A lych gate was built as a war memorial around 1920, at a cost of around £1,000. On the *Rotherhamweb.co.uk* section about Anston a piece on the church reads: 'There are old sedilia and a double piscina, and in one of two old recesses rests an unusual sculptured stone showing a man at prayer, an angel touching the head of the tiny woman at his side. It may be 14th century.'

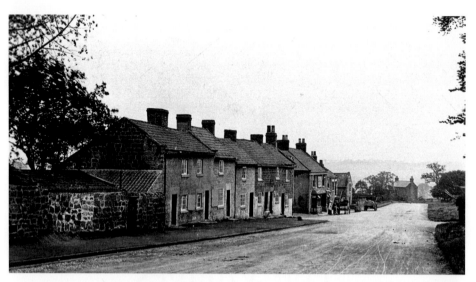

Bawtry Road or Bramley Hill, facing east, with the old Ball Inn visible in the distance. Interestingly, the *Rotherham Advertiser* (23 April 1949) notes, 'Bramley occupies a proud place in the world of Methodism.' In 1786, John Wesley preached in the Methodist church there, afterwards lunching with General Spencer, a well-known local landowner of the period. The church had been opened the previous year by the Revd Joseph Benson. Copies of the text used by both speakers have been typed and affixed on the underside of the stool from which Wesley preached, which is still present at Bramley.

According to The Rotherham Rural District Council By-Law Building Plans 1897–1947, the first plans for housing in Cross Street, (stated as being Ball Lane) Bramley, were submitted in 1905. This was for the development of a number of properties by Waddington, Francis and Balby. The view here shows Cross Street looking north, with the Ball Inn, rebuilt around 1912, on the right.

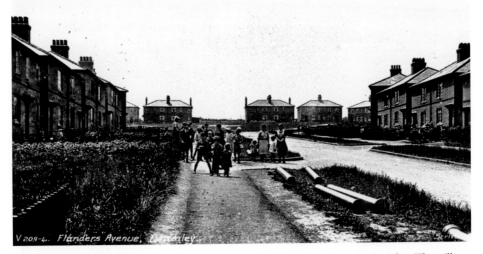

Flanderwell (not Flanders as mentioned on the postcard view) Avenue, Bramley. The village, lying east of Rotherham, has been noted as retaining its rural charm until well into the twentieth century.

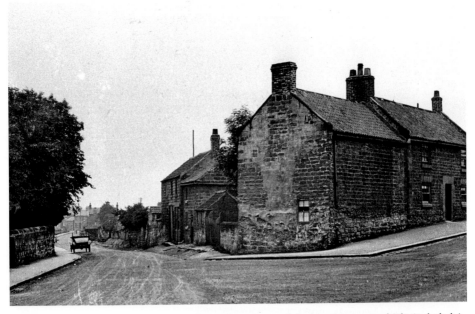

Main Street, Bramley, with photographer Edgar Leonard Scrivens' motor vehicle included in the picture on the left. It is noted in H. Wild's *Rambles In Ivanhoe Land*, [n.d.]: 'The village of Bramley, which lays away from the High Road, with the exception of a few cottages and the two inns The Ball and the Travellers Inn, is a pleasant walk from Rotherham, the four mile stone stands at the roadside just before one enters the village near the lodge of Bramley Park.'

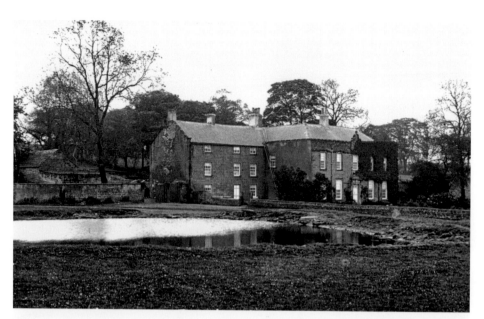

Wild (*op. cit.*) states: 'Bramley Grange ... in former days was a Grange of the Abbots of Roche [Abbey] ... only one end can have any claim on being the original monastic building, the following restoration dates, 1639, 1716 and 1755 appearing in various parts of the house. When, after the dissolution of the monasteries, their [the Abbots] wealth and belongings were parcelled out, Bramley Grange, for a century or two was in the hands of the Spencers [for nearly 300 years].'

Bramley chapel was erected in 1785 for Mathew Waterhouse on his own land. The building bears the inscription, 'John Wesley preached here July 1st 1786'. John Wesley, then over eighty, had accepted Waterhouse's invitation to preach in the new chapel, which he described in his journal as 'a neat preaching house for the poor people'. The building was closed in 1972 and converted to a private dwelling, *c.* 1975.

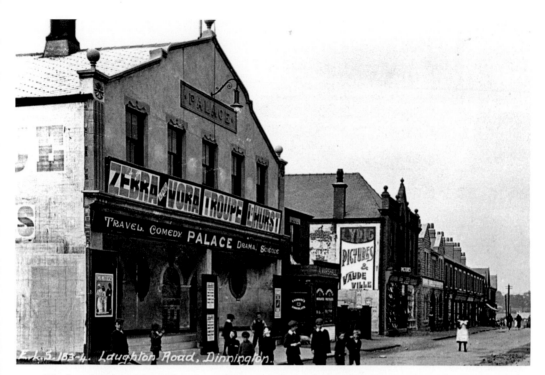

Dinnington Palace cinema/theatre was built around 1915 by James England and some local businessmen. The building was eventually converted to a supermarket. Allan Harvey in *Palace Cinema* (1980) recalls that the establishment of the cinema was a great step forward for the area and a real money-spinner. For the first year of the Palace there was a break in the film's programme for a live stage show. Full houses were usual and the best seats had to be reserved. The film's programme consisted of Pathé's Gazette, the serial, the main feature and a comic to finish. Off-centre to the right is the Lyric theatre, built in 1910, James England being the main instigator. England's son Fergus was involved in much of the construction work. Two flats were contained above the entrance and there were two down below. Allan Harvey notes that the actors who came to the Lyric and the Palace usually lodged in New Street, then a very respectable area. He also adds, 'The Lyric had prosperous and lean years.' At one time it was a Salvation Army Citadel, though during the Second World War it had a revival and was a popular venue for dancing. The Lyric was bought by the local Parish Council in 1962 for £1,800.

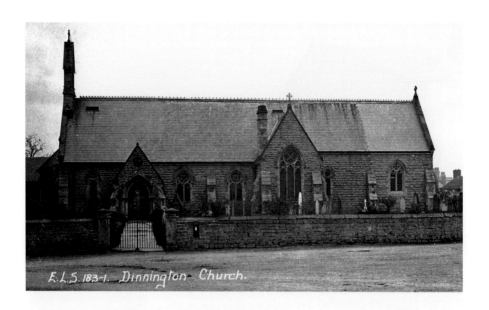

E.L.S. 183-1. Dinnington Church.

The church of St Leonard, at Dinnington, was rebuilt in 1868 at the expense of John Carver Athorpe. It is a building of limestone, in the Gothic style, its features including a turret containing one bell. Several stained-glass windows in the church are to the memory of various members of the Athorpe family. The church was enlarged in 1906 by the erection of a new north aisle, the extension of the nave and the addition of vestries. In 1911, the chancel was rebuilt and extended and new choir stalls added as a memorial to the late Revd G. M. Athorpe, rector 1870–82, at a total cost of around £900. There were about 350 sittings.

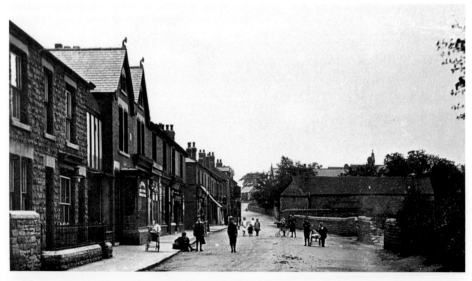

Scene in Laughton Road, Dinnington. During the 1920s, it was claimed that all the streets in Dinnington were well lit by gas supplied by the Dinnington Gas Company, which also provided for the needs of those requiring light and heat for domestic purposes. Allegedly, the 'gas was good and the price exceptionally low'.

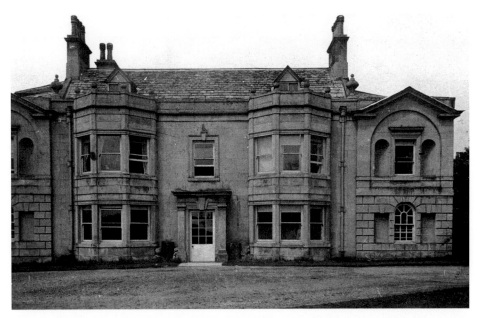

It is claimed that the original Dinnington House/Hall was built by Henry Athorpe in 1756. In time he was succeeded by his nephew Robert Athorpe, who made the house more imposing. The house was later purchased from the Athorpe family by the National Coal Board.

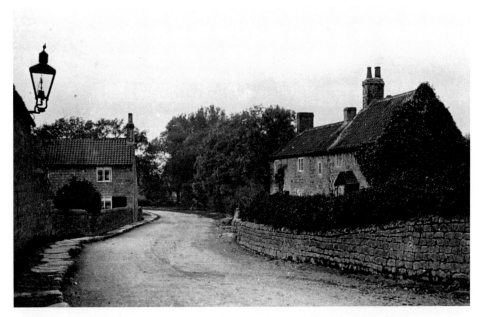

A little bit of old Dinnington. Excavations show Dinnington to have been inhabited since at least Neolithic times, and it has been suggested that the settlement takes its name from a local barrow, though a more traditional interpretation of 'Dinnington' would be 'Dunn's Farmstead'.

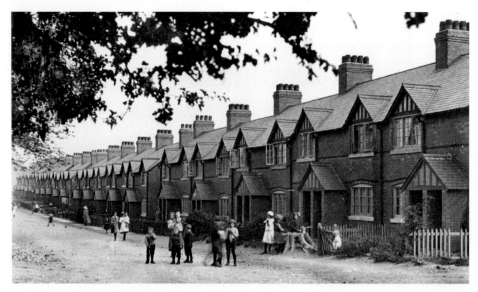

Doe Quarry Lane, Dinnington. In 1900, Dinnington's population was 285. By the Second World War, it was about 7,500. Up to 1900, there were just a few farms, the old inn and a small Methodist chapel. Quarrying in the area helped expand the population but the sinking of the colliery in 1905 changed all that, turning a small hamlet into a village of urban dimensions.

View of Lorden's Hill, Dinnington. In the Dinnington 1937 *Coronation Souvenir*, edited by Herbert Frith, it is stated that: 'There are streets of splendid shops, well equipped for serving the community; banks and post offices; cinema; concert hall, which give a town-like appearance to the village.' By 1950, it was recorded that Dinnington had 112 shops – a total which gave the area one shop for every seventy people – an average higher than Rotherham or Worksop. The commercial premises, fronting the building in the picture, have since been converted to a private dwelling.

Two pictures of Dinnington Colliery, one of five collieries owned by the Amalgamated Denaby Collieries Ltd, comprising Denaby, Cadeby, Maltby, Rossington and Dinnington. The sinking of the shafts at Dinnington started in September 1902 and then March 1903, with the Barnsley seam reached in February 1904 and February 1905 respectively. Coke ovens were attached to the colliery in 1907. Also adjacent was a brickyard, producing good, sound engineering bricks. By the late 1930s, it was recorded that the colliery owned 715 houses in the village and found employment for a gross total of approximately 1,700 men and boys. A set of pithead baths was installed in 1937 for the workmen. In 1992, Dinnington Colliery was closed with a loss of 1,000 jobs, devastating the local community. A business park on the colliery site, and small-scale commercial redevelopment has gone some way towards a recovery.

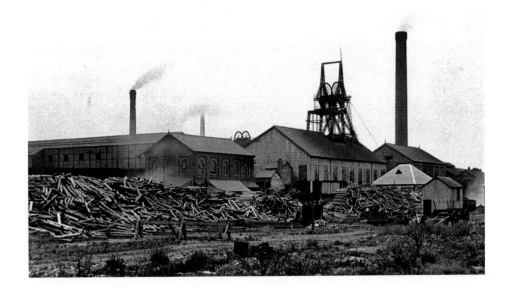

Dinnington's *Official Guide* (c. 1925) states that the Colliery Institute 'is the chief centre [of recreation] and home of sport and pastimes of every description – indoor and outdoor. Its large and handsomely furnished billiard room contains six first-class tables. It housed a large concert hall, library, reading room, card rooms etc. Here were to be found the headquarters of the various sections of sport. The grounds of the institute are laid out for football, cricket, bowling, tennis etc. and are considered to be amongst the best in the region. The Yorkshire County Cricket team have been entertained there on several occasions, on one of which – be it never forgotten – Dinnington almost won.'

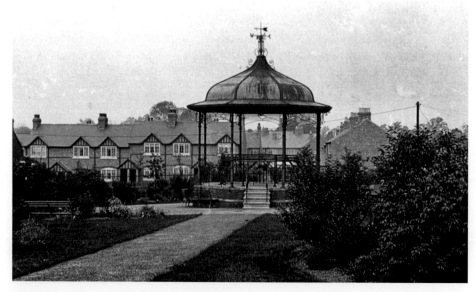

The Bandstand, Coronation Park, Dinnington.

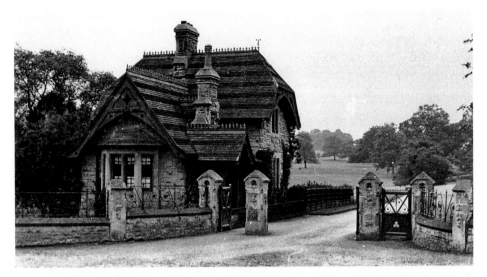

The Lodge, Firbeck Hall. After the death of former hall owner Henry Gally Knight, the Firbeck Estate including the hall, was put up for sale in 1852 and was described thus: 'Surrounded by beautiful gardens and pleasure grounds, with sheets of ornamental water in the midst of park like meadows, screened from the north and west by thriving plantations, and is approached by three lodge entrances.' The hall is reputedly haunted by a 'Green Lady'; believed to be the daughter of a former owner who drowned herself in the hall's lake when her Roundhead lover was killed.

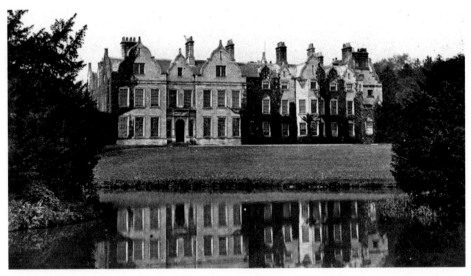

Commenting on Firbeck Hall in 1828, historian Joseph Hunter said: 'An old Elizabethan fabric, but when in [Henry Gally knight's hands] has been made to fall in with views of modern convenience and elegance.' From this, it was assumed that Henry extended the hall, and to quote historian Sir Nicholas Pevsner, 'Elizabethanised it by the addition of steep gables'. During the remainder of the nineteenth century, the hall had several owners including, a Mrs Miles of Bristol and the Revd Henry Gladwyn Jebb. In 1914, the building was home to several Belgian families. Around 1934, Cyril Nicholson acquired the premises and converted them into a country club. Later, the building became an annex for the Sheffield Royal Infirmary.

Interestingly, Norman Hill, in the *Postal History of Rotherham & District* (1960), mentions that the Firbeck mails were first carried by a rural letter-carrier (foot-post, postman) from Tickhill. A wall box was opened on 4 November 1870. The post office, under Rotherham, opened on 3 May 1890, with Mary Elizabeth Ward as sub-postmistress. Telegraph business commenced on 25 July 1893.

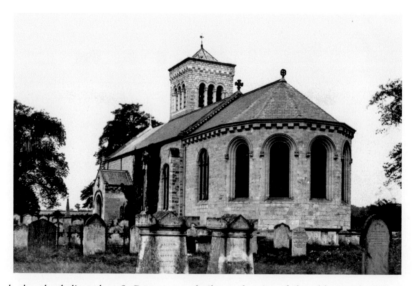

Firbeck church, dedicated to St Peter, was rebuilt on the site of the old one, during 1820–21, by Mrs Gally Knight. On the south side of the chancel is a monument for Sir Ralph Knight, of Langold, and Faith, his wife; there are also several inscriptions upon the floor for some of their children. Nearly opposite to Sir Ralph Knight's monument is one of the West family of Firbeck, a family of considerable account, but long since extinct. There are also several inscriptions in the chancel floor for the Staniforth family. In the churchyard there is a headstone with the inscription: 'Isabell Robinson of Stone, buried November 22nd, 1694 age 114 years. Also James Robinson, son, was buried July 24th 1730 aged 109 years.'

The *South Yorkshire Times* of 19 August 1916 announced that sinking operations at the Firbeck Colliery, Langold, had begun. The *Rotherham Advertiser* of 16 May 1925 noted that the Barnsley seam was reached at a depth of 826 yards. *Wikipedia* states: 'At its peak in 1953, the mine employed 1,448 underground workers and 393 surface workers. Problems gradually occurred, as the mine was affected by water, ventilation difficulties and geological faults. Transport of the coal to the surface was slow, as the shafts were unsuitable for the installation of mechanical skip winding, and by 1968, the mine was deemed to be uneconomical. It closed on 31 December 1968, and many of the miners moved to other local pits at Maltby, Manton, Shireoaks and Steetley.'

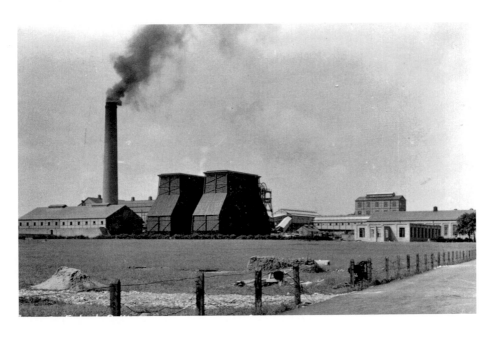

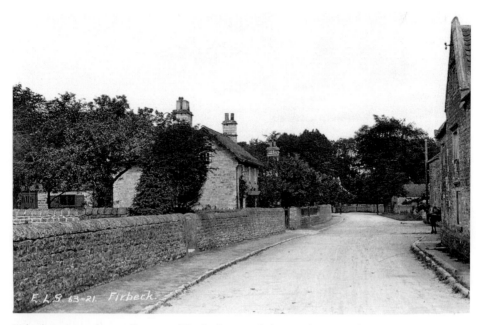

Firbeck is situated ten miles east of Rotherham, and the population at the time the picture was taken around 1920 was 203. The residents involved in commerce included grocers, farmers, market-gardeners and joiners.

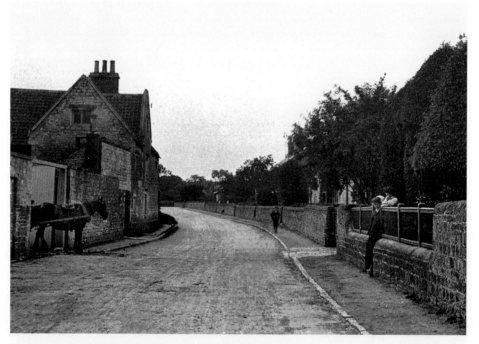

Street scene, at Firbeck. The name is said to derive from 'Friebec', meaning a wooded stream. An oval field in the village marks what was once the private racecourse of eighteenth-century racehorse owner Anthony St Leger, who originated the St Leger Stakes.

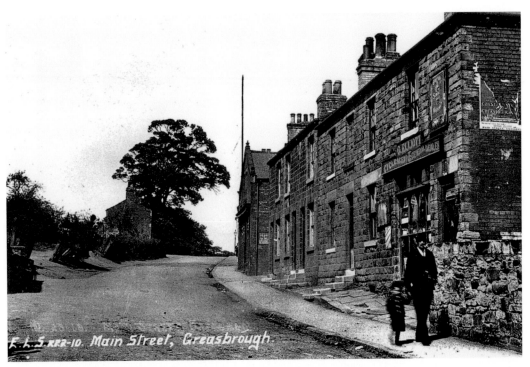

Main Street, Greasbrough, with cycle agent and general dealer G. Elliot's business premises on the right.

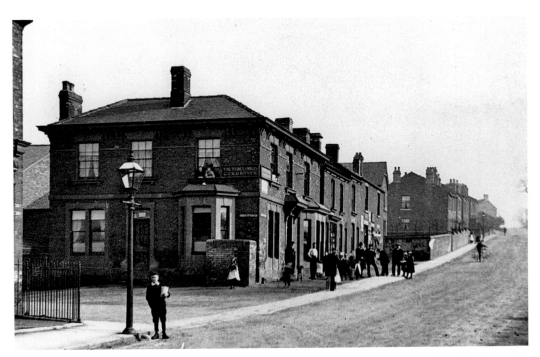

Potters Hill, Greasbrough. Scrooby Street is to the left, along with the Prince of Wales public house, the licence dating from 1868.

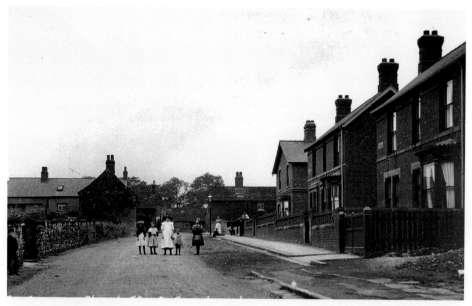

Church Street, Greasbrough. Greasbrough village is two miles north of Rotherham and its township once included the neighbouring hamlets of Basingthorpe, Ginhouse, Nether Haugh and part of Parkgate. A local board was established in 1873, but this was superseded by an Urban District Council of twelve members formed under the Local Government Act of 1894.

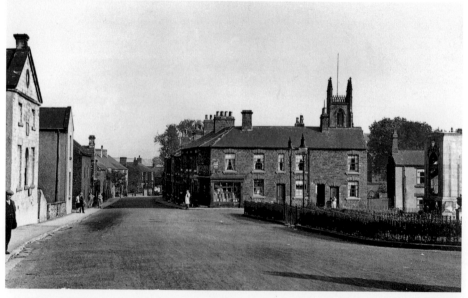

Church Street, Greasbrough, with the War Memorial on the right. Greasbrough has a gothic-style church called St Mary's, which was completed in 1828 at the cost of £6,000, of which £2,000 was granted by Parliament. A school is attached to the church. There are also Wesleyan and Independent chapels, similarly with attached schools. At one time there were four Methodist chapels in Greasbrough: the United Methodist Free Church was built in 1854; the Congregational Chapel in 1874; the Primitive Methodist in 1880, and the Wesleyan Chapel in 1893.

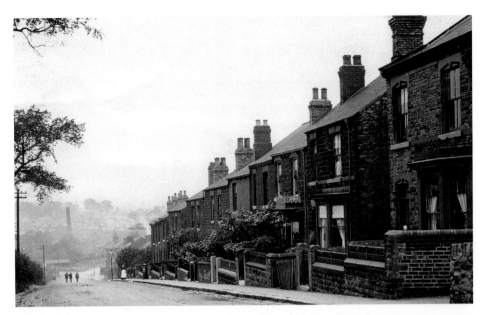

Potters Hill, Greasbrough. The population of Greasbrough during the early 1920s was just over 3,000 and in the ecclesiastical parish was 2,665. The area of the township and urban district comprised of 2,413 acres, of which 2,376 were land and 37 water. Earl Fitzwilliam was formerly the principal landowner.

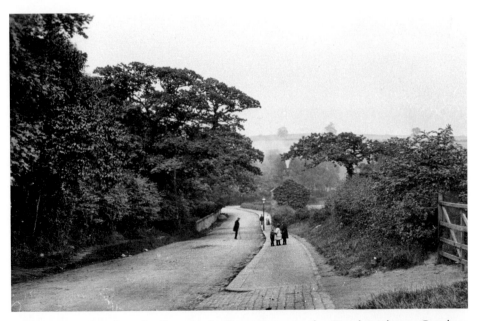

Toll Bar Lane, Greasbrough. In 1086 the Domesday name for Greasbrough was Gersebroc and probably means 'grassy brook' (Source: *A Dictionary of British Place-Names in Names & Places*). A Roman coin hoard consisting of eleven antonianini of Gordian I, Trebonianus Gallus, Postumus, Victorinus, Claudius II, Tetricus I & II, and Probus (AD 238-282), now in Rotherham Museum, was found in Wagon Road allotments. It was a late third-century hoard.

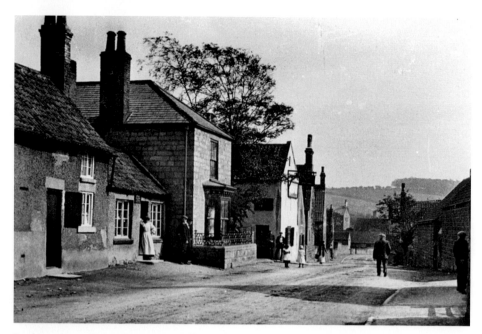

Looking down Union Street, Harthill, towards Serlby Lane. It has been said that the period 1901–37 saw the beginning of great changes in Harthill. 'The old, dusty, limestone roads were gradually macadamised, the wagonette and gig gradually disappeared, and the telephone and telegraph appeared...' The single-story building on the left was, for many years, a sweet shop occupied by Mrs Featherstone.

Greasbrough, with the parish church of St Mary's in the distance. The foundation stone for the structure, designed in the Gothic style by Charles Watson and J. P. Pritchett, was laid on 29 September 1826 by Viscount Milton. The church was consecrated in 1828. C. Wilson in *Greasbrough – A History* explains that with the village's population rising during the first quarter of the nineteenth century, the old chapel of ease – the Chapel of Holy Trinity – was inadequate for the number of Anglican people residing there. Earl Fitzwilliam and the people of Greasbrough provided a site for the new church. It was adjacent to the old chapel that was demolished.

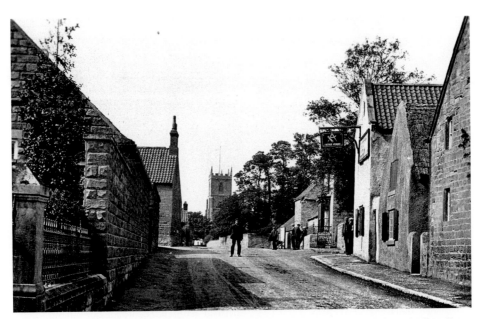

Union Street, Harthill with the Square and Compass public house on the right, and All Hallows Church in the distance. *Harthill and Woodhall* (1989) mentions that there has been a church on this site for at least 900 years. It is thought that a church was built in 1085 and was dedicated to St John the Baptist. The present dedication to All Hallows came sometime before the nineteenth century. Very little now remains of the Norman church.

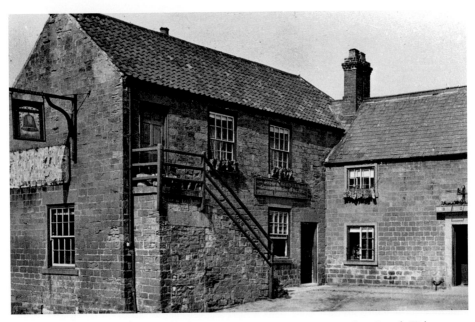

Blue Bell public house, Harthill. The photograph was taken at a time when Joseph Webster was noted as the 'licensed retailer of beer and spirituous liquors.' Garbett, in *Harthill with Woodhall* (1950), records that the pub, demolished and rebuilt in 1923, had a fine old malt kiln at the rear and was the home of a branch of the Glossop family from around 1680 to 1830.

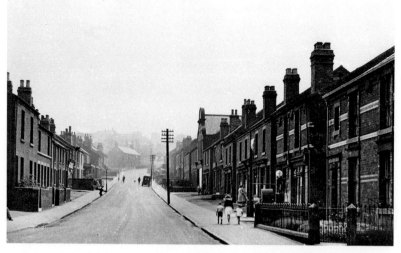

Bridge Street, Killamarsh. In the nineteenth and twentieth centuries, Killamarsh became a thriving mining town as the burgeoning Sheffield iron industry demanded coal and transport links with Sheffield matured. The first major mining operation opened at Norwood resulting in an almost doubling of the Killamarsh population between 1861 and 1871. The last two pits, Westhorpe and High Moor, are now gone, casualties of the early 1980s pit closure programme.

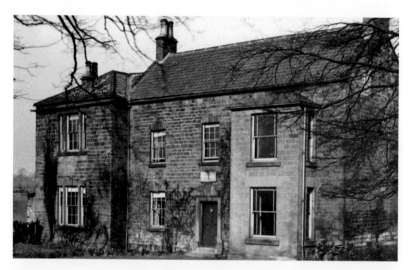

The Vicarage, Hooton Roberts. The village is situated on the main road from Rotherham to Doncaster, and many of the properties that make up the community are situated along it. The church, anciently known as St Peter's, was built around 1100 by Robert de Hoton. The latter's son, Sir William, succeeded him in about 1130, but the village did not bear its name until 1285, when another Robert de Hoton, to distinguish it from its neighbours Hooton Levitt, and Hooton Pagnell, added his own name. This Robert seems to be the last of the de Hotons. At the beginning of the twentieth century, Hooton Roberts' main commercial occupants were farmers. Other people listed included a gamekeeper, a quarry owner, and Elizabeth Wilson, who was the shopkeeper and postmistress. The population of Hooton Roberts at the time the picture was taken, around 1910, was 245.

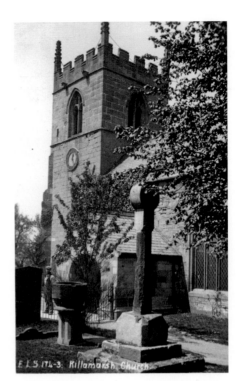

Killamarsh was mentioned in the Domesday
Book with the name 'Chinewoldemaresc' or
'Chinewolde' meaning 'Cynewalds Marsh'.
N. Pevsner in *Derbyshire* (1953) says that the
interest in Killarmarsh's church of St Giles is
'the Norman doorway (one order of colonettes,
capitals with leaves, arch with zig zag in
intrados and extrados). The Late Perps window
should also be noted in which all curved forms
of Gothic arches have gone straight.'

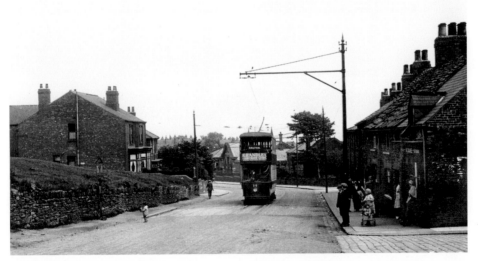

Rotherham Corporation tramcar No. 14 is pictured at Kimberworth. Peter Gould on his
website gives details of tram operations on the Kimberworth route: 'On the 8th April 1903 a
third [Rotherham tram] route to Kimberworth, via High Street, Main Street and Masborough
Street commenced.' And he also details its closure: '[P]roposals for reconstruction of the road
at Thrybergh meant that it would be necessary to relay the track and it was decided to replace
the tram service by trolleybuses. Since the Thrybergh trams ran through to Kimberworth, it was
further decided to replace the whole route, and, on the 16th May 1931, the Kimberworth to
Thrybergh route was replaced by a trolleybus service.'

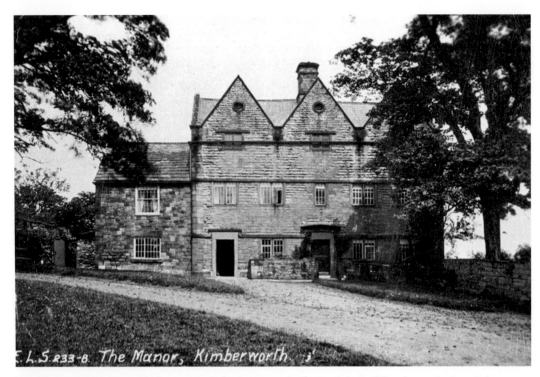

Two views of the Manor, Kimberworth. A datestone on the front of the building bears the inscription '1694'. In the picture below, a dovecote from the seventeenth or early eighteenth century can be seen in the foreground. Kimberworth castle (now demolished) was located near the Drawbridge pub.

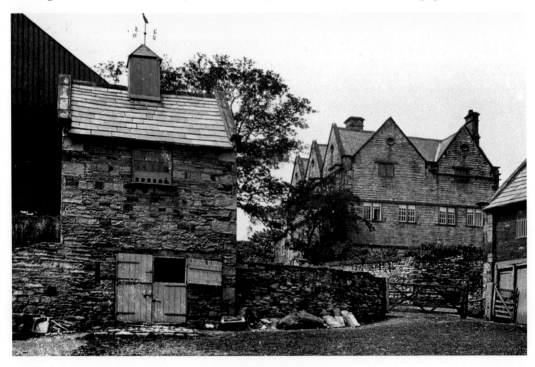

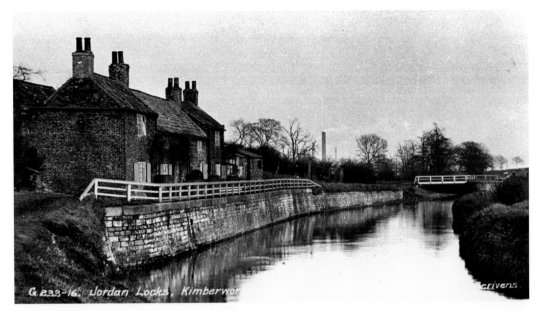

Jordan Locks, Kimberworth. In C. Wilson's *Kimberworth Manor, Township and Parish* (1988), it is said that Kimberworth is more than a village on a hill. It has been an ancient manor since Anglo-Saxons lived there a thousand years ago. It was a separate township from 1756 until its combination with Rotherham when the County Borough was created in 1871, and it has been an ecclesiastical parish since 1841.

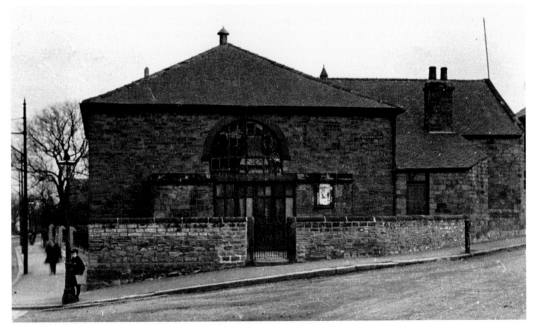

Kimberworth Wesleyan chapel, at the junction of Kimberworth Road and Psalters Lane, was opened in 1904 at a cost of £2,500. It seated 300 adults and 480 children. Behind the building is the Kimberworth Trinity church.

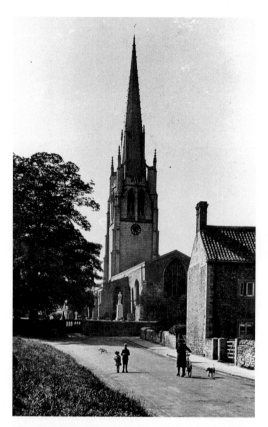
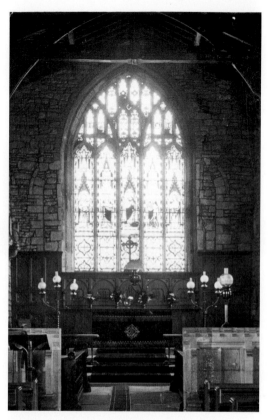

The church of All Saints at Laughton is a building of limestone principally in the Early Perpendicular style, being the third church on the same site. It consists of chancel, nave, aisles, south porch and an embattled western tower with pinnacle and spire rising to a height of 185 feet. The church contains a remarkable doorway belonging to the first Saxon church. There is a monument to the Eyre family, dated 1619, another to that of Hatfield (long-term residents at Laughton) and two kneeling figures of Richard and his wife, of New Hall Grange, dated 1605. The first church dates from around 1200; the church was restored in 1896 and afforded 500 sittings. To the west of the church is the site of Earl Edwin's castle.

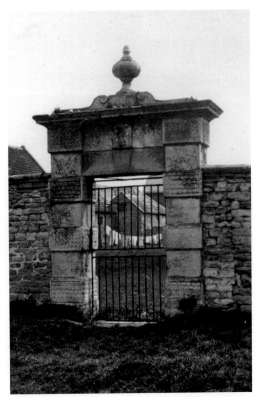

An old gateway, Laughton. There are also two public houses in the village, the St Leger Arms (named after local landowners the St Leger family) and the Hatfield Arms, which is also named after a well-known local family.

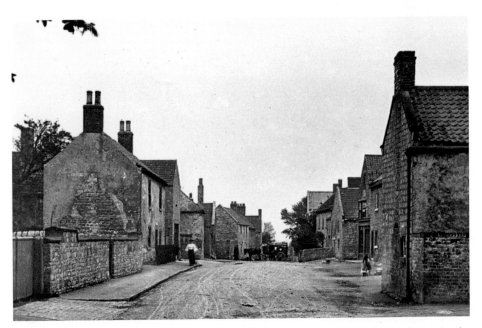

High Street, Laughton. The population in 1901 was 631 in the township and 926 in the ecclesiastical parish. At one time in the village, there was a police station of the West Riding Constabulary, with one constable and two cells.

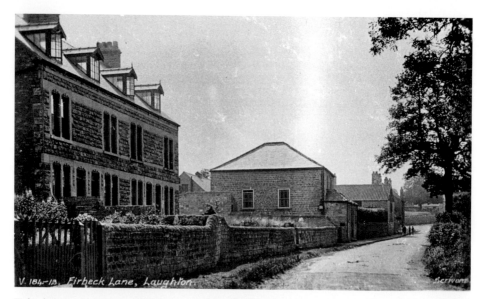

Firbeck Lane, Laughton. There was an increase in Laughton's population from 1901–31. One of the reasons for this occurred in 1904, when the South Yorkshire Joint Railway was built, bringing railway workers to the area. In the Second World War a German bomber on his way back from a raid on Sheffield dropped an unused bomb on the village, which failed to go off. Local farmer Henry Turner, whose family still live in the village, towed the bomb to safety across his fields.

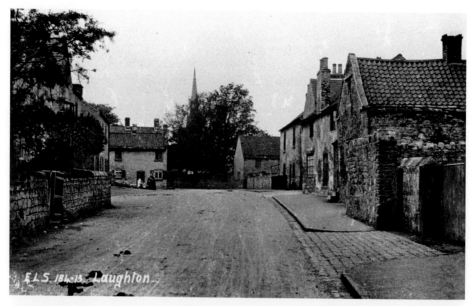

C. W. Wright in *The Character of Laughton-en-le-Morthen* (1967) says the curiosity of newcomers to the village must immediately be aroused by the stark contrast between the old village of Laughton and the nearby red-brick colliery villages: 'Although Laughton lies on the official green belt of Rotherham and Sheffield, it is surrounded by its own green belt of agricultural land into which the colliery villages have not been allowed to intrude.'

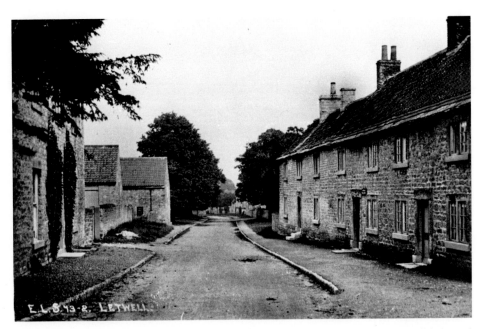

Street Scene, Letwell. It is claimed that in Norman times, the land that is now Letwell belonged to Tickhill castle and was first cleared out of the forest for farming purposes. The village is farmed locally, it also has an octagonal red-brick eighteenth-century dovecote, and there is also a nineteenth-century dovecote in the village. The census of 2001 recorded a population of 111.

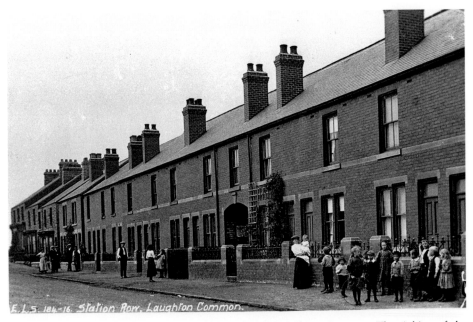

Scrivens has captured a lively scene at Station Road, Laughton Common. The sinking of the Maltby, Dinnington and Firbeck collieries led to a further increase in Laughton's population.

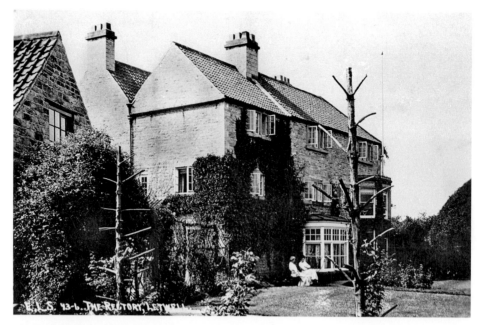

The three-storeyed Letwell rectory was built in the eighteenth century, for a yeoman farmer, and features mullioned windows. A brass quote on the doorstep reads, 'Peace and grace be to this place.' Letwell's church of St Peter was rebuilt, with the exception of the tower, about 1820 in the place of a more ancient church at the expense of Henry Gally Knight. It was damaged by fire in 1867, when all that remained were the outside walls; it was restored by 1869. Letwell has a number of other listed Georgian buildings, including farm cottages and a village hall.

It is suggested that Letwell may have acquired its name from all the wells in the vicinity, while piped water was first brought into the village in 1935, at a cost of £25,000. Main sewers were laid in the late 1940s. Until then earth closets had been used.

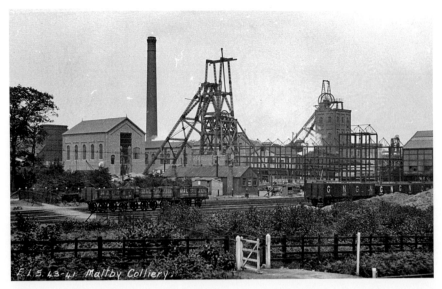

The sinking of Maltby Main colliery began in 1908, and the task was not without several mishaps. On 31 March 1909, three men were killed, and on 19 August of the same year, a man was fatally injured falling down the shaft. On 17 June 1910, the sinkers' efforts were rewarded, a rich seam of the Barnsley bed being struck at a depth of 820 yards.

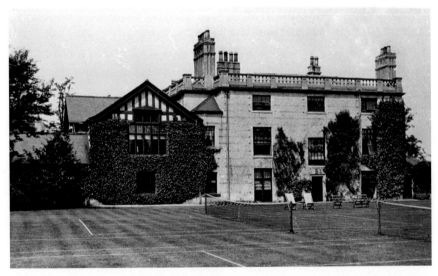

The garden front, Hooton Levitt Hall, Maltby. On *Rotherhamunofficial.co.uk* it is stated: 'By the late 18th Century, Hooton Levitt Hall was the home of the Hoyle family. William Hoyle who was clerk to the Cutlers Company in Sheffield married Barbara, heiress of John Fretwell of Hooton Levitt Hall. His grandson, William Fretwell Hoyle (1801–86) was a Rotherham lawyer and Steward of the Manors of Rotherham and Kimberworth. He was rumoured to have lost a good deal of his money speculating in tin mines. [It has not been possible] to find out if he still owned the house when he died in 1886 or who owned or inherited it after that. Hooton Levitt Hall was demolished in the 1960s to make way for modern housing.'

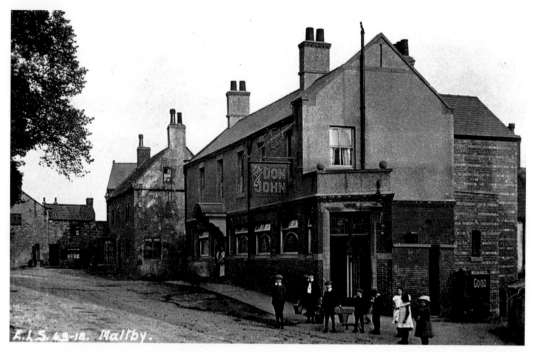

The Don John public house at Maltby. The village remained quite a small place until the twentieth century. The population in 1811 was only 602, and it had reached no more than 716 by the 1901 census. However, within the next ten years, the colliery had started production, as had the local brickworks, and the population had now more than doubled to 1,750.

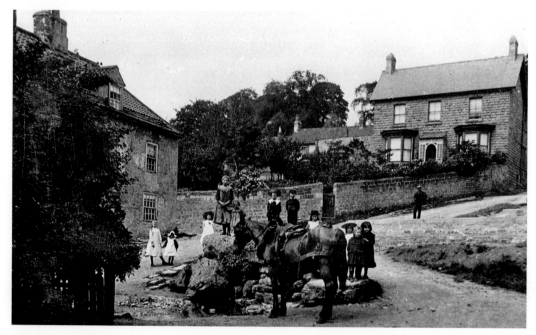

The well at Maltby.

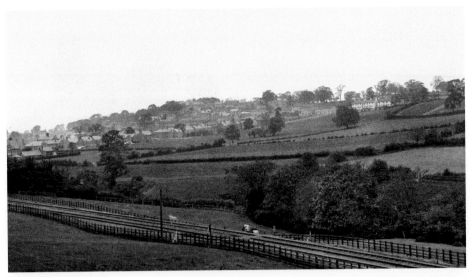

North Anston's panoramic view. The villages of North Anston and South Anston are generally known simply as Anston, although the Post Office now officially recognises South Anston in its own right (this change occurred due to postal confusion with nearby Aston and also because of petitions of local residents). Anston was already established as a settlement by the time of the Domesday Book (1086), when North and South Anston (Anestan and Litelanstan) were under the ownership of Roger de Busli. The name Anston is thought to derive from 'an stan' (a stone) as opposed to anything based on the suffix-ton, and there is much evidence of quarrying in the area. *Wikipedia* states: 'The surrounding landscape [of North Anston] contains several disused quarries: the plantations to the east, and Greenlands Park to the west being prime examples.'

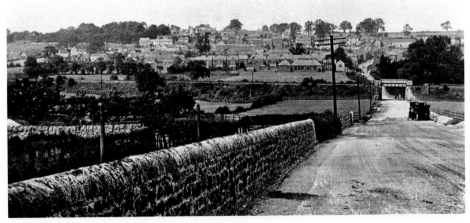

North Anston, seen here from the South Anston end of Ryton Road, with the area up to the railway embankment undergoing much redevelopment in the intervening years. The new A57 road now bypasses the village. The area where the steam lorry can be seen is dissected by Anston crossroads and has been known as an accident black spot.

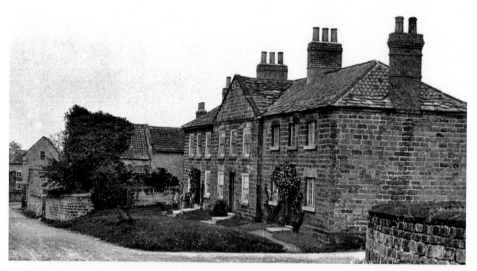

Main Street, Ravenfield, with Garden Lane to the right and Pingle Lane to the left. Thomas Bolle Bosvile, of Ravenfield Park, was once Lord of the Manor and sole landowner. The old Ravenfield village is situated in a fold in the hills close to the site of the now demolished Ravenfield Hall and adjacent to Ravenfield Park. The estate was sold in 1920 when the park was broken into separate farms. Many of the old barns have been demolished or converted into homes. Nevertheless, the village has represented Yorkshire in the national Britain in Bloom competition winning medals on three occasions. In 2008 the village won a gold medal as well as best in category.

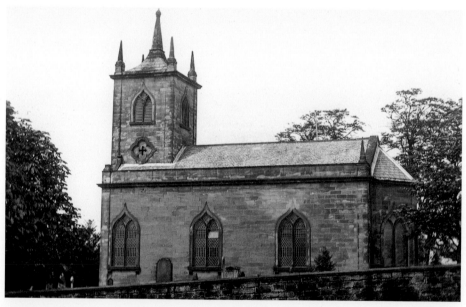

Ravenfield church, dedicated to St James, was erected in 1756, to the designs of the York architect John Carr, on the site of the medieval church. It is a plain building of stone, consisting of chancel, nave and square tower containing six bells. St James's was restored in 1895 and afforded 140 sittings.

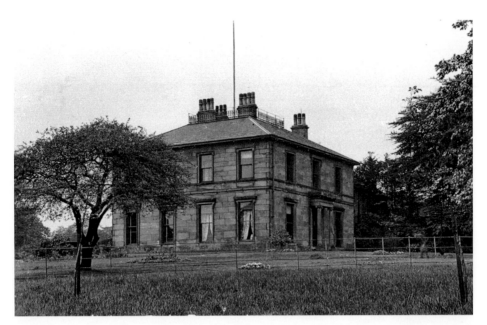

The former Victoria Park Hall/Rosehill Park Hall was converted in 1966 to a café and branch library on the ground floor and two flats on the first floor. The area of the whole parkland was noted as 34 acres and the land was purchased for £4,000 in 1900, being officially opened by W. H. Holland MP on 27 May 1901. On 9 April 1973 a new building was erected in the park at a cost of £6,000 for use by aged persons as a day centre and was furnished with the aid of grants from the West Riding Social Services Committee to help form the basis of a meeting place for aged persons in the district.

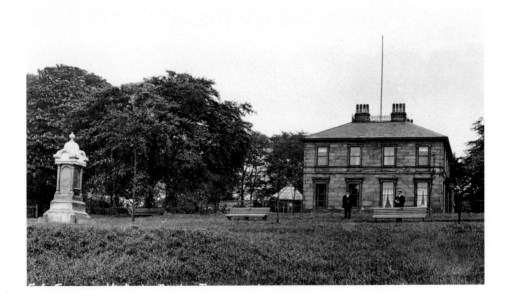

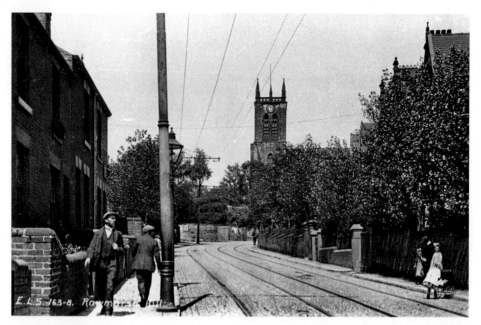

The parish church of St Mary the Virgin is shown dominating the landscape from the top of Rawmarsh Hill. The church dates from 1838 when an earlier tower was increased in height and all the rest rebuilt. The architect was J. P. Pritchett. In 1869, the tower was rebuilt incorporating the features of the original Norman doorway. In 1894 further redevelopment took place, with vestry, organ chamber and north porch being added.

Another view of Rawmarsh with the council offices and library on the right. The *Rawmarsh Official Guide* of 1953 said the complimentary industries of steel and coal were the basis of working life in Rawmarsh. An approximate derivation of the name Rawmarsh is 'Red Marsh' possibly accounted for by the town's situation on the Permian system of red sandstone and marls which runs through this part of South Yorkshire.

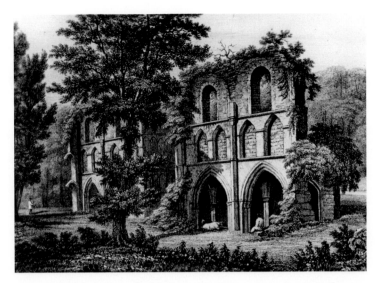

One of the only examples discovered of Scrivens copying an engraving to make a postcard view is of Roche Abbey around 1820. The area has been described as 'a pile of stately ruins – beautiful even in decay, which but faintly convey a slight idea of its former great extent, and splendour of structure'. With their usual eye for a perfect situation, the Cistercian Order of Monks founded a retreat at Roche, around the year 1150, and here in this beautiful rock-bound valley, with its rippling streams, their successive generations for 400 years exercised their various functions. In the early twentieth century the abbey ruins were presented to the nation by the Earl of Scarborough.

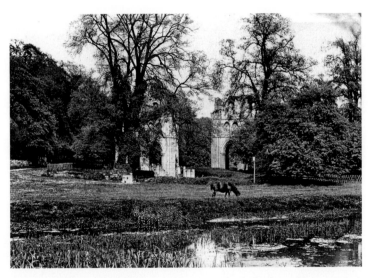

Roche Abbey, seen from a distance. In 1776 the Earl of Scarborough commissioned noted landscape gardener Lancelot 'Capability' Brown to create a beauty spot from the ruinous area. But with an astonishing disregard for history, Brown demolished buildings, built large earth mounds and turfed the whole site. Until the end of the nineteenth century Roche Abbey remained buried beneath Brown's work and wooded parkland. But subsequent excavation in the 1920s returned Roche to its former splendour. There are several local legends revolving around Roche Abbey, particularly concerning ghosts, tunnels to other buildings, and even a lost wishing well.

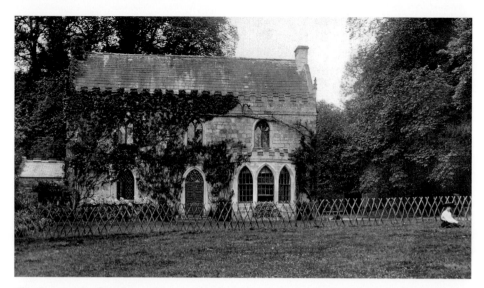

The Cottage, Roche Abbey. The remarkable chronicle of the destruction of Roche Abbey was written by Michael Sherbrook, a priest and rector of nearby Wickersley who watched the pillaging by the local community at time of the dissolution in 1538. They had decided to have first right of claim on Roche Abbey and its possessions, Sherbrook commenting: 'For the church was the first thing that was spoiled; then the abbot's lodging, the dormitory and refectory, with the cloister and all the buildings around, within the abbey walls ... For nothing was spared except the ox-houses and swinecoates and other such houses or offices that stood outside the walls – these had greater favour shown to them than the church itself.'

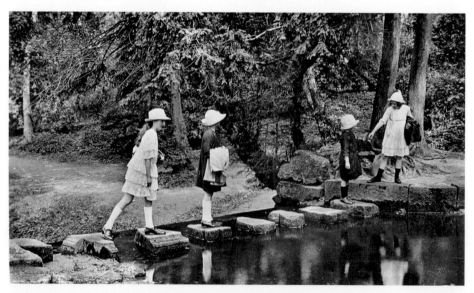

The stepping stones at Roche Abbey, featuring, it is believed, two of photographer Scrivens' daughters. The site is now in the care of English Heritage. The cliff path walk provides access to a view across the abbey grounds where its layout can be appreciated. Many of the buildings are low-standing but the walls of the church still stand to full height and the gothic French idealism thrust into its design and architecture is visible.

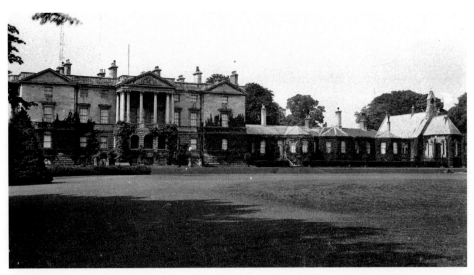

Two views of Sandbeck. The first recorded house at Sandbeck was built around 1626 by Sir Nicholas Saunderson. Sir Nicholas's family was succeeded by the Lumleys in 1724 when James Saunderson left Thomas Lumley his large estates in Lincolnshire and Yorkshire. Among these were houses at Sandbeck and Glentworth. Thomas Lumley was a younger son of the 1st Earl of Scarborough, becoming 3rd Earl of Scarborough, his elder brother predeceasing him. Plans survive from this time for remodelling the house but were never carried out, probably due to Thomas's lack of finances. Thomas died in 1752 and his son and heir married in the same year, to Barbara Saville living at Glentworth. In the following year, the couple engaged James Paine to produce plans for altering Glentworth, but these were never carried out. Preferring to live at Sandbeck, they then moved there. James Paine was first called to Sandbeck in 1757, making a number of drawings for a variety of the Earl's building plans. Eventually, Paine produced ideas to make alterations and additions to the old house. Then came a payment of £52 10s for 'preparing the several workmen's instructions by his Lordship and directing the building of the north and south ends and their intermediate part of the east front'. Incomplete records for the time introduce some doubt as to when the work was carried out, but it is thought to have taken place around 1760. Other records suggest that the house was remodelled rather than rebuilt.

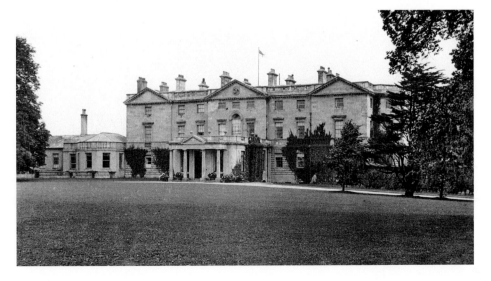

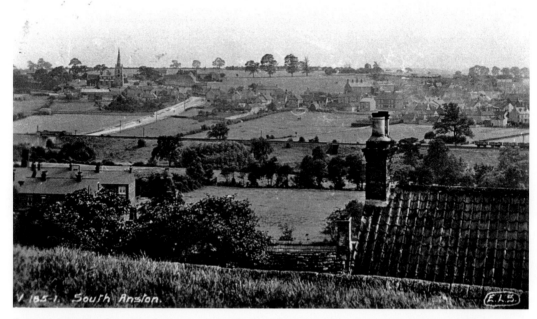

A panoramic view from North Anston to South Anston prior to the construction of the A57 bypass. William White, in 1838, said: 'Anston contains the well built and pleasant villages of North and South Anston situated on opposite acclivities of the fertile vale of a small rivulet which flows eastward to the Ryton, twelve miles east – south-east of Sheffield, six miles west of Worksop, in the heart of limestone district.'

West Street, looking towards Sheffield Road where the Methodist chapel, built in 1871, can be seen in the distance. In 1934, this chapel was superseded by another, built on an adjacent site (Chapel Yard) in the memory of James Turner JP. An alleyway on the left, where the man and child are noticeable, leads to Maltkiln Yard. At the time the picture was taken J. W. Moor was the licensee of the Leeds Arms, on the right.

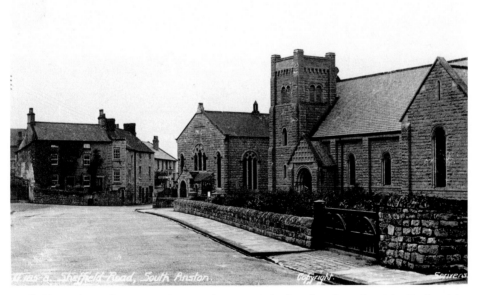

Sheffield Road, South Anston, showing the new Methodist chapel on the right. Designed by B. D. Thompson of Worksop, it was erected in memory of James Turner and built in the Norman style of Southwell Minster.

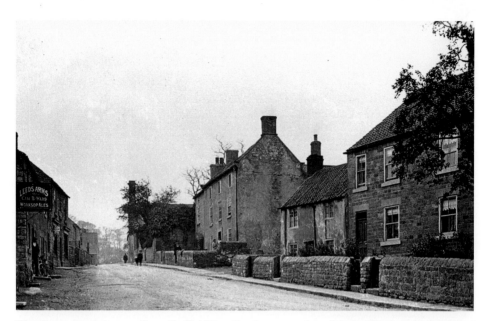

West Street, South Anston (from Sheffield Road), where a number of the buildings on both sides of the street have been demolished or drastically altered. Historically, South Anston was principally a farming community, though many hands were employed in related industries including quarrying for sand and stone. During 1846, South Anston Methodists found accommodation in the Lodge Rooms over the stables of the Leeds Arms (on the left). Gardens of Remembrance now replace the three-storey building on the right.

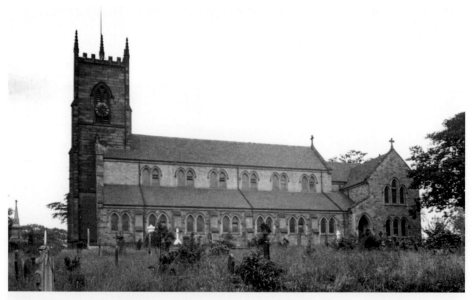

The church of St Margaret, Swinton, built in 1816, was destroyed by fire in March 1897, with the exception of the tower. It was rebuilt, partly from the remains of the old one, at a cost of over £6,000, and afforded 600 sittings. There is a memorial window to the Revd John Levett, vicar there from 1851–95; the organ, provided at a cost of £680, was dedicated in January 1903.

Scene on the bowling green, Welfare Ground, Swinton.

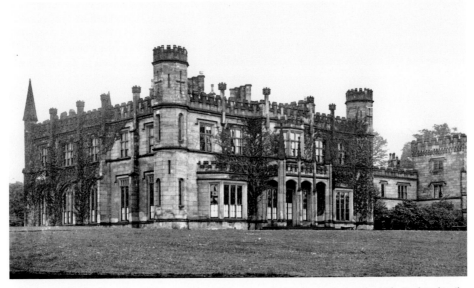

Thrybergh Hall is a late Georgian castellated house, in the Tudor revival style with Gothic details; the front is symmetrical with angle turrets and porch. Col. John Fullerton employed John Webb to build the house. Another house had existed near the church. In an article headed 'Thrybergh Park Estate – to be sold for building purposes', the *Doncaster Chronicle* of 4 January 1929 recalled that the hall was formerly the home of the Rearsby family. 'The estate eventually came into the possession of the Fullerton family, and it has now been sold by J. S. Fullerton, a former master of the Badsworth Hunt.' The newspaper added that the Thrybergh estate included the mansion house, park, Rotherham golf course, five farms, several secondary residences, woodlands, twenty-three cottages, freehold ground rents and a large area of valuable building land ripe for development.

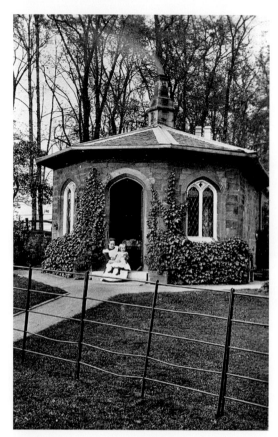

The Lodge, Thrybergh. The hall and its ground are now occupied by Rotherham Golf Club and its website states: 'In 1814 the then owners of Thrybergh, the Fullerton family, sold a large amount of timber from the estate in order to raise money to build a magnificent new gothic residence (now the Clubhouse). The Golf Club was formed in 1903 and there are few clubs in the UK that can claim such a glorious location and magnificent Clubhouse. Surrounded by beautiful timbered parkland the course is easily accessible from the M1 or A1 in South Yorkshire. Originally a nine hole course laid out by Sandy Herd, in 1906 it was increased to eighteen holes and was subsequently modified by James Braid. Resulting from this is an exceptionally well laid out course, where golf is played over parkland of great beauty.'

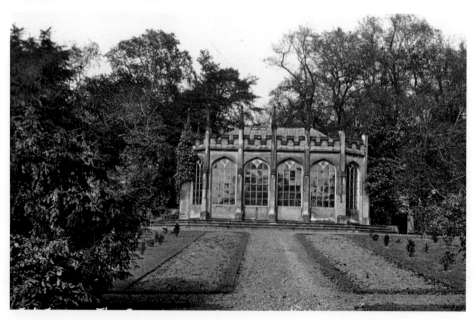

The greenhouse, Thrybergh Hall.

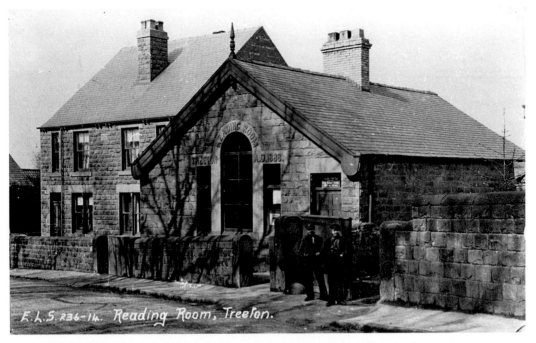

In his *Parish Study of Treeton* (1969) J. P. Dannatt says the village hall or 'Reading Room' serves many purposes: 'It is a small sub-library of the WRCC. It is also used for dancing classes, Treeton Horticultural Society meetings...' More recently the Reading Room has been used by a pre-school group.

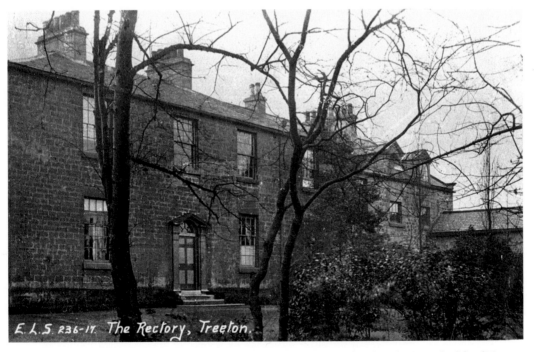

The Rectory, Treeton. Until the arrival of the railways and associated coal mines, the life of Treeton village was strictly rural. From 1881–91 the population tripled from 482 to 1,301.

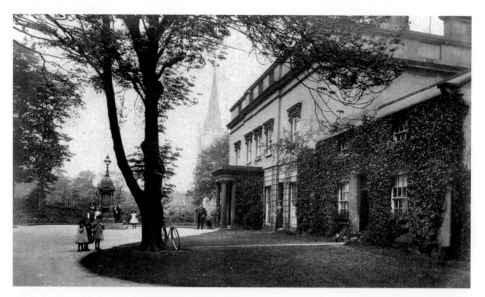

Wath Hall, built in 1770, occupies the former site of a fourteenth-century manor house. Its occupants have included William Kaye, James Barton (who used it as a boarding school) and Frederick Johnson, its last resident. On the left, in the above picture, is the memorial for the local brewer, Spedding Whitworth. In 1891, the hall was sold to Wath UDC for £2,500, becoming Wath Town Hall.

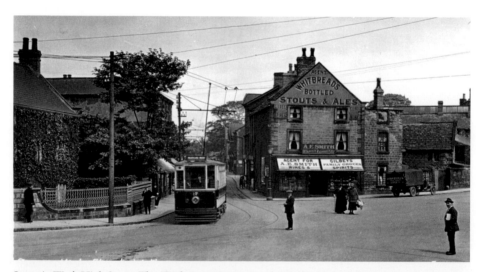

Scene in Wath High Street. The *Wath-upon-Dearne and District Almanack* of 1914 mentions that Wath's principal industries were the Manvers Main Collieries (Nos 1, 2 and 3 pits), the Wath Main (Nos 1 and 2 collieries) with the new coking plants; the Great Central Railway Company's new concentration yard; Messrs Chas Stanleys & Sons oil, manure, chemical and soap works; Whitworth, Son & Nephew's breweries and malt house; and the gasworks. Occupation was also found for a considerable number of workers by the local builders, contractors, farmers, etc. The population in 1912 was 12,392. Plans were mooted for a tramway system serving Wath before the First World War, but the construction of a route through the town did not begin until the early 1920s.

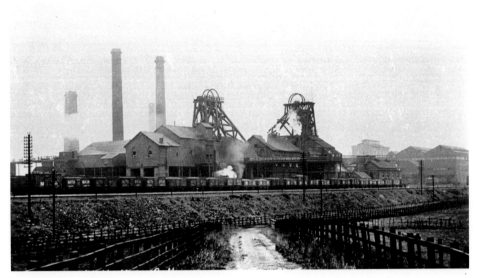

The sinking of Manvers and Wath Main Collieries, made mining the principal source of employment in the area for many years. Wath Main Colliery was operated by the Wath Main Coal Company Limited and after the sinking of the first of its two shafts in 1873, the workings reached the highly prized Barnsley seam three years later. To gain access to lower reserves the shafts were deepened, first in 1912 to reach the Parkgate seam and then, in 1923, to the Silkstone seam. The colliery was amalgamated, along with other local collieries, with the adjacent Manvers Main Colliery on 1 January 1986 and closed on 25 March 1988.

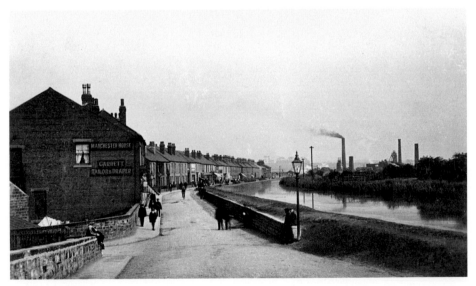

Doncaster Road, Wath, with Nash Row and the Manvers Main Colliery in the distance. The Dearne & Dove Canal, completed in 1797, is on the right. Manchester House (a drapery store) and Common Lane, are on the left. The canal was a very profitable investment to its shareholders, being the main outlet for the coal trade before the coming of the railways.

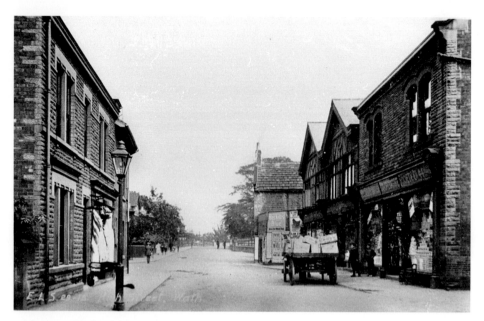

High Street, Wath, with the Co-op on the right.

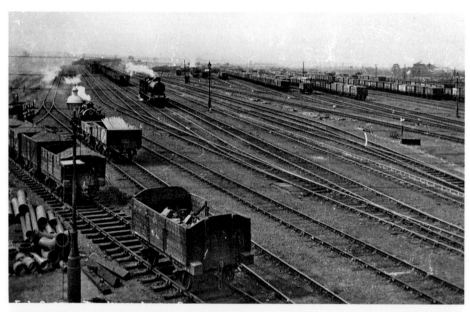

Panoramic view of the Hump, Wath Sidings. In the article 'Wath concentration yard & the Wath Daisies' (GCR Rolling Stock Trust) and extracted from *wikipedia* it is stated: 'The yard was set to the south of the main line from Doncaster and Barnsley. It was built on the 'hump' principle, where trains were uncoupled and then propelled over a hump, allowing the wagons to run by gravity into sidings to await collection. However unlike later hump yards it was built without automatic retarders to slow the rolling wagons down. Instead the yard employed human runners who chased the rolling wagons to pin down their hand brakes and control their movement through the sidings. This was a particularly hazardous occupation.'

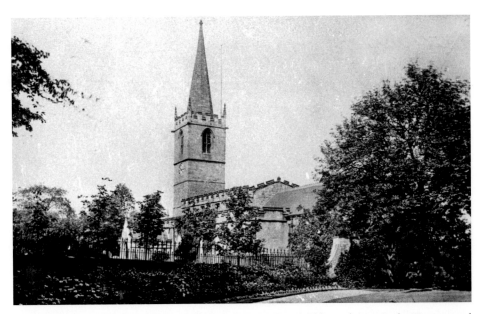

View of Wath church. The church of All Saints is an ancient building of stone in the Norman and Early English styles, and consists of chancel, nave, aisles, south porch and tower with spire. The stained-glass east window was given by the late Miss Alice Otter in 1851, and at the restoration of the church in 1868 the two centre lancet lights of the north window were filled with stained glass by Messrs John and William Johnson as a memorial to Samuel Johnson and Ann, his wife. There were sittings for 517 persons, the register dating from 1598.

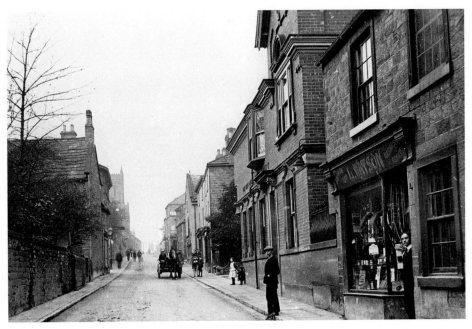

High Street looking west. On the right is Lewis Watson's business premises. Adjacent is the London, City & Midland Bank.

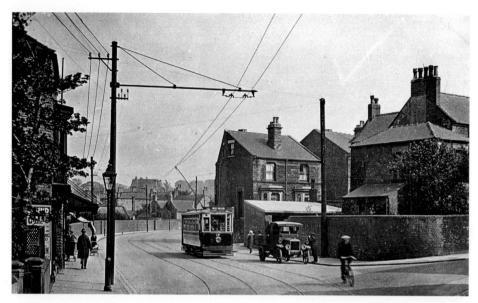

Montgomery Road, Wath. John Murray on the website Barnsleyandfamily.com gives an account of the introduction of trams into Wath: 'The Dearne District Light Railway was originally planned in 1915, but World War 1 delayed its completion until 1924. A fleet of 30 single deck trams, with 36 seats, were built by the English Electric Company at Preston, in 1924/5 for the service. The line was a joint venture between the councils of Wombwell, Wath and Bolton-on-Dearne to provide a frequent service to Barnsley from outlying villages. The system opened on 14th July 1924 and ran from the Alhambra Theatre, in Barnsley, via Doncaster Road through Stairfoot, Wombwell and West Melton to Wath-upon-Dearne, where a low bridge precluded the use of double-deck tramcars.'

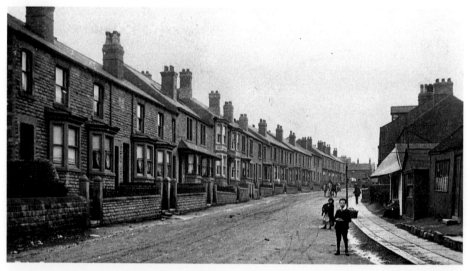

A scene in Melton Road, Wath. The area's most famous son, James Montgomery (1771–1854), the Scottish poet, hymn writer and newspaper editor was so fond of the place that he referred to it as the 'Queen of villages'. Although Montgomery's residency was quite brief his undoubted affection for Wath has been immortalised locally in a number of ways, most notably in place-names such as Montgomery Square, Montgomery Road and Montgomery Hall.

View of Burman Road, Wath. Wath was once described as a township, and was an extensive parish and town situated on a pleasant acclivity near the Dearne and Dove canal, with stations on the Wath and Kirk Smeaton branch of the Hull and Barnsley railway, on the South Yorkshire branch of the Great Central railway and on the main line of the Midland railway. Earl Fitzwilliam was formerly Lord of the Manor.

Looking along Cross Street, Wath. After the Second World War the collieries clustered around Manvers were developed into a large Modern colliery complex, coal preparation, coal products and coking plant, which was not only visible, but detectable by nose from miles around.

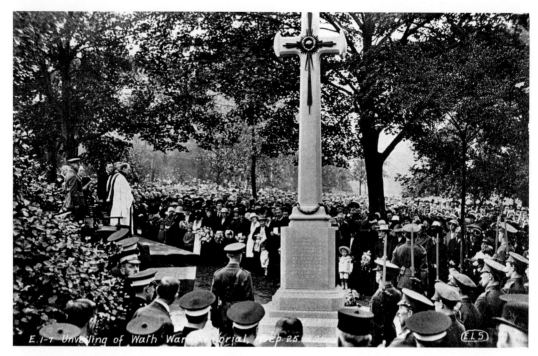

Unveiling the Wath War Memorial, 25 September 1921.

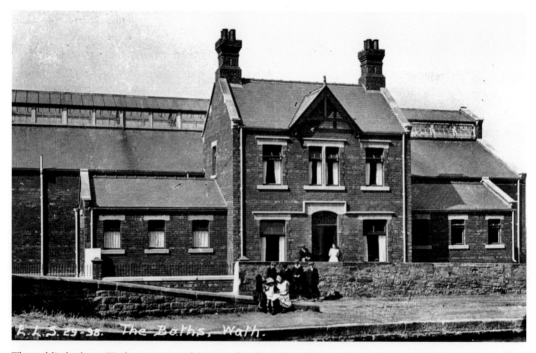

The public baths at Wath were opened in 1911 by the Urban District Council at a cost of £2,500.

Wharncliffe Crescent, Wath. The local coal industry was at the forefront of the sudden dramatic decline of the British coal mining industry in the late 1970s and early 1980s, and this had very severe knock-on effects in the many reliant local industries, causing much local hardship. Along with the whole of the Dearne Valley, Wath was classified as an impoverished area and received much public money, including European funds. Regeneration took place from the mid-nineties onward causing a certain amount of economic revival. Large areas of ex-industrial land to the north of the town once occupied by collieries and railway marshalling yards were turned back into scrubland and countryside, dotted with light industrial and commercial office parks.

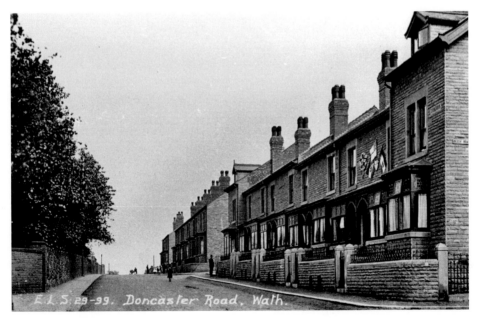

View along Doncaster Road, Wath.

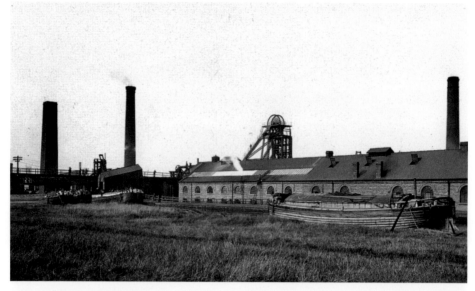

After conducting sinking operations, which extended over a period of 15 months at the new shaft at Manvers Main Colliery, near Wath, coal was reached at eleven o'clock in the morning on Monday 15 April 1901. The hoisting of a small flag on the top of the winding gear was the outward visible token of this interesting fact. The new shaft was close to Manvers Main No.1 pit, being separated on the surface only by the Great Central Railway running from Mexborough to Barnsley. The coal reached was part of what was known as the Parkgate seam, found at a depth of 550 yards. Eighty men were employed in shifts in the sinking of the shaft and not one injury was suffered by a workman. Unlike most other collieries, Manvers was not the centre of one village inhabited chiefly by its employees. The workmen lived principally at Wath, Swinton and Mexborough, with a few at Bolton, Adwick and Barnburgh.

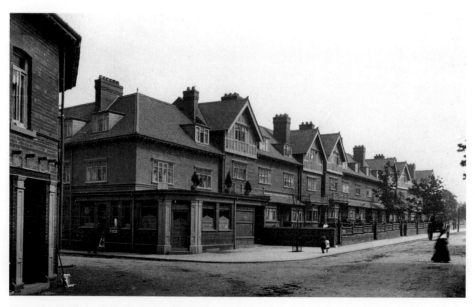

View along Wharncliffe Crescent, Wath.

Church House, Montgomery Square, Wath. Brian Elliott in *Wath-upon-Dearne the Queen of villages* (www.aroundtownpublications.co.uk) gives details of the property: 'The most handsome early nineteenth-century building facing the Square is Church House, now a Wetherspoons 'Free House' pub but formerly the home of William Carr who built it as his residence when it was called Cross House, after the medieval market cross which once stood nearby. It became a 'church house' in 1912 when sold by William Camden.

Looking along Doncaster Road, Wath. Today Wath is still emerging from the hardship caused by the sudden collapse of its major industry. However, over the past decade jobs and a certain (albeit relatively low) level of affluence have returned to the area. In very recent years, after a hiatus between the clearing of the former colliery land and the recent redevelopment when the area felt rather rural, the construction of large distribution centres to the north of the town is once again bringing an industrial feel to the area, although without the pollution issues that were connected with the coal industry.

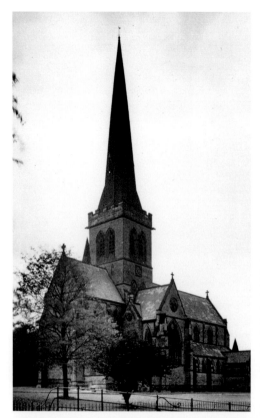

Wentworth has a long association with the Fitzwilliam family. The Wentworth Holy Trinity church was designed by J. L. Pearson and built between 1873 and 1877 at a cost of around £25,000. It was erected in the memory of the parents of William, the 6th Earl of Fitzwilliam, and in that of his wife Harriet, the Countess Fitzwilliam. Many items in the church commemorate the Fitzwilliam family. Several Earls and Countesses Fitzwilliam are buried in a private cemetery at the rear of the church.

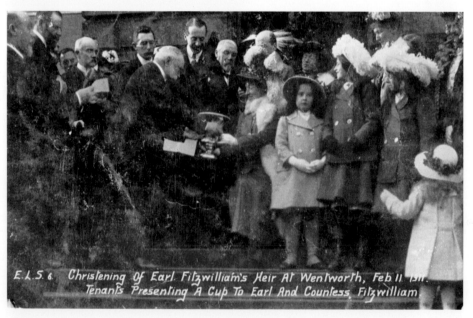

E.L.S. 6. Christening Of Earl. Fitzwilliam's Heir At Wentworth, Feb 11 1911.
Tenants Presenting A Cup To Earl And Countess Fitzwilliam

Wentworth tenants present a cup to the Earl and Countess Fitzwilliam at the christening of Earl Fitzwilliam's heir at Wentworth on 11 February 1911.

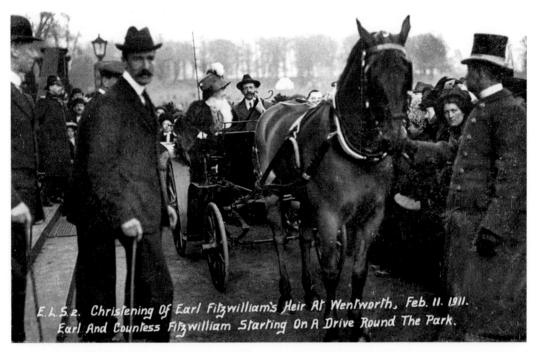

E.L.S.2. Christening Of Earl Fitzwilliam's Heir At Wentworth, Feb. 11. 1911.
Earl And Countess Fitzwilliam Starting On A Drive Round The Park.

The Earl and Countess Fitzwilliam, starting on a drive round the park, at the christening of Earl Fitzwilliam's heir.

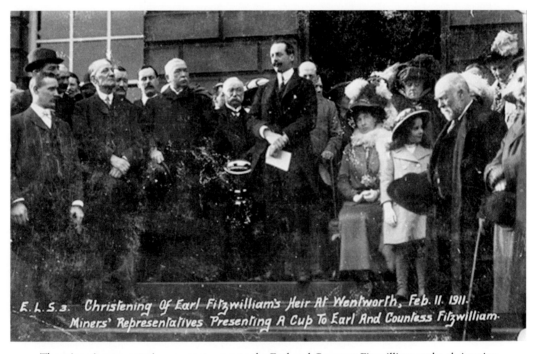

E.L.S.3. Christening Of Earl Fitzwilliam's Heir At Wentworth, Feb. 11. 1911.
Miners' Representatives Presenting A Cup To Earl And Countess Fitzwilliam.

The miners' representatives present a cup to the Earl and Countess Fitzwilliam at the christening of Earl Fitzwilliam's heir.

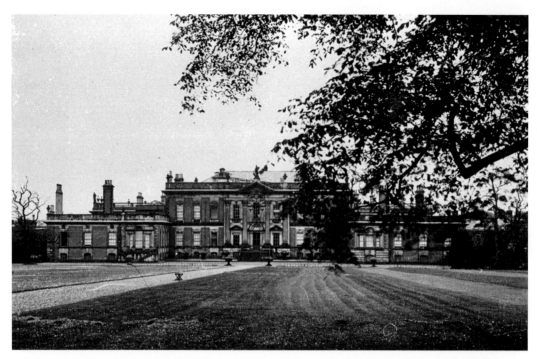

Wentworth Woodhouse, often called the most extraordinary house in England, has the longest façade (606 feet) of any private house in the country. Thomas Watson Wentworth, 1st Earl and Marquess of Rockingham began building the house in 1724. The interior, equally as remarkable as the exterior, covers most of the styles of the eighteenth century. The view above shows the Garden Front, more commonly known as the Back Front.

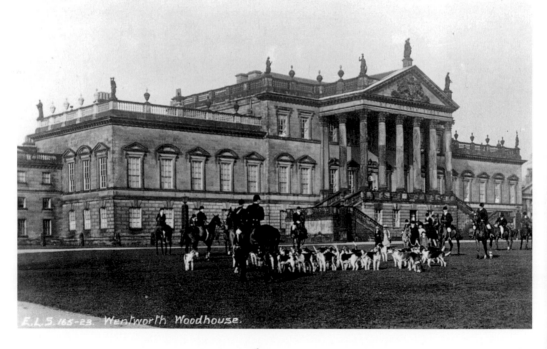

E.L.S. 165-23. Wentworth Woodhouse.

Greasbrough Lodge, Wentworth Park.

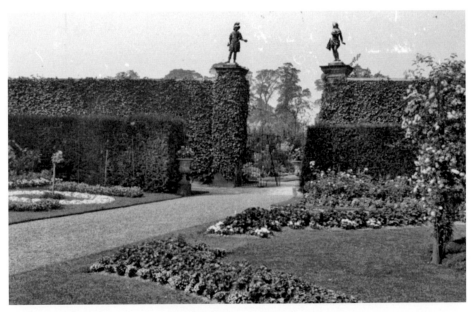

In the gardens, Wentworth Woodhouse. During 1790 Britain's most prominent landscape gardener, Humphry Repton, was employed at Wentworth to carry out many alterations and he would detail his work in *Some Observations of the Theory and Practice of Landscape Gardening* (1803). Repton found there were few trees, the house being surrounded by 'coarse grass and boulders' which he removed, before the large-scale earth-moving operations began, effected by men with shovels and donkey-carts, to reshape the lumpy ground into smooth swells. Two large pools visible from the East Front and the approach drive, were excavated into a serpentine shape. Besides that many trees were planted.

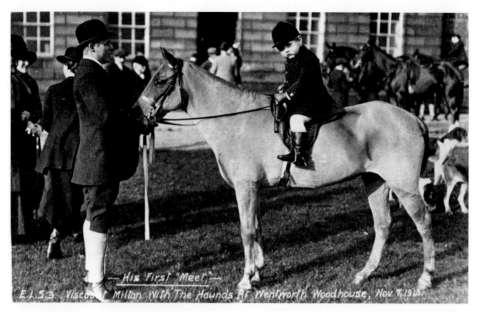

This picture shows Peter Fitzwilliam being introduced to hunting. The groom in attendance is a Mr Dawes. There were Wentworths at Wentworth from the thirteenth century, right up until 1695. The estate passed to the Watson family in that year and then to the 1st Marquis of Rockingham in 1746. The 2nd Marquis died in 1782, and the estate passed to the 4th Earl Fitzwilliam. The estate then remained with the Fitzwilliams until the 10th Earl died in 1979. Thereafter, there being no heir, the estate was divided.

The Mechanic's Institute, built in 1835, and described as 'an extraordinary Gothic exercise with corner turrets, [once] provided a Christian men's working club'. At one time it was said to contain a library of 3,500 volumes.

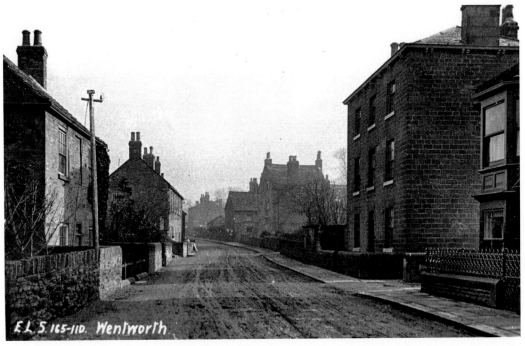

E.L.S. 165-110. Wentworth.

Two views of Wentworth Woodhouse village, said to be an exceptional and fascinating agricultural estate village, in the small rural enclave of South Yorkshire, beleaguered on all sides by the encroaching sprawl of Rotherham, Sheffield and Barnsley, and only a few miles east of the M1. It is the central estate village of the old Fitzwilliam estate, once an outstanding example of a fully orchestrated village, developed and maintained by the estate for the occupation of its workers over centuries. The houses and cottages in the estate village are built of soft, local sandstone, with massive graded stone tiles.

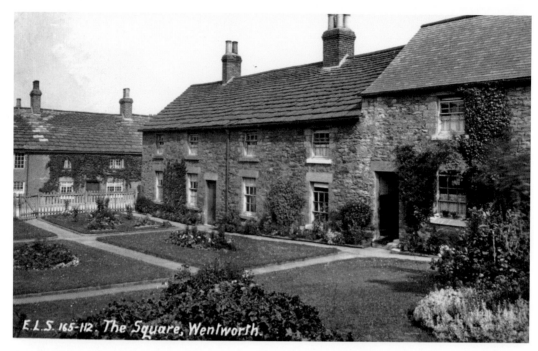

E.L.S. 165-112. The Square, Wentworth.

Paradise Square, formerly a farm with cottages and outbuildings placed around the farmyard. The picture was taken in front of the farmhouse, looking towards the main street.

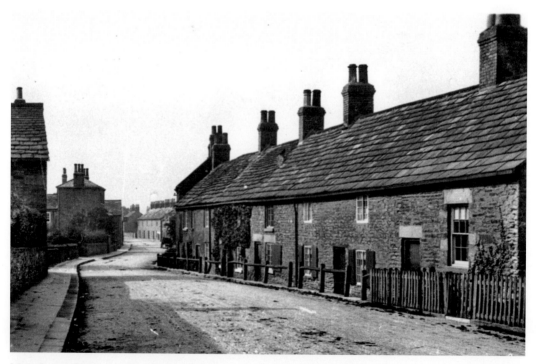

Main Street, Wentworth Woodhouse. The road was macadamised around 1914.

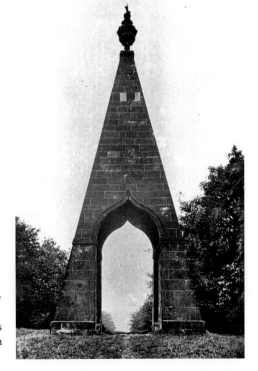

Within the Wentworth Woodhouse estate are a number of follies/monuments, built during the eighteenth century, satisfying a contemporary craze for that type of feature. These include Hoober Stand, Keppel's Column, the Needle's Eye and the Mausoleum. The latter was designed by John Carr and built in 1788 by the 4th Earl Fitzwilliam in memory of his uncle the 2nd Marquis of Rockingham, who was twice Prime Minister. The statue of the 2nd Marquis of Rockingham inside the mausoleum is by Nollekens.

The Needle's Eye, dating from 1780, and lying at the edge of Lee Wood, is the smallest of the four major monuments. It is a 45-foot (14 m) high, sandstone block pyramid with an ornamental urn on the top and a tall Gothic ogee arch through the middle, which straddles a disused roadway. It was built allegedly to win a bet after the 2nd Marquess claimed he could drive a coach and horses through the eye of a needle.

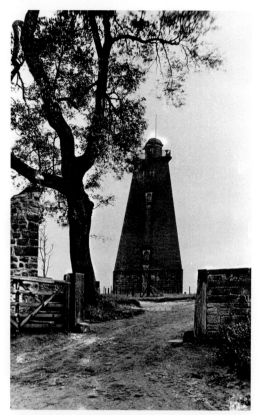

Hoober Stand, a triangular and tapering structure with a hexagonal lantern, extending 30 metres high, was named for the ancient wood in which it was erected. Built to Henry Flitcroft's design in 1747–48 it supposedly commemorates the quelling of the Jacobite Rebellion in 1745 in which Lord Malton and his surviving son took part; his defensive efforts for the Hanoverian Whig establishment were rewarded with the Lord Lieutenancy of Yorkshire and the title Marquess of Rockingham: thus the monument indirectly reflects the greater glory of the family.

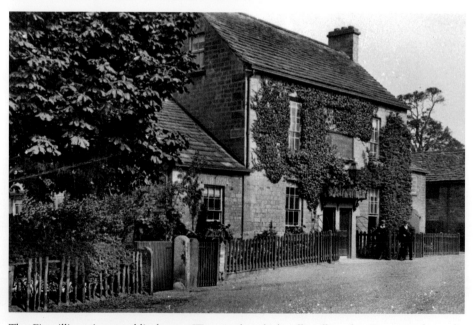

The Fitzwilliam Arms public house, Wentworth, which, allegedly, takes its name from the Marquess of Rockingham in the eighteenth century.

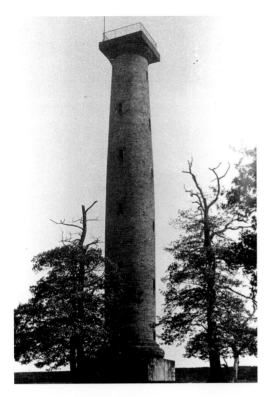

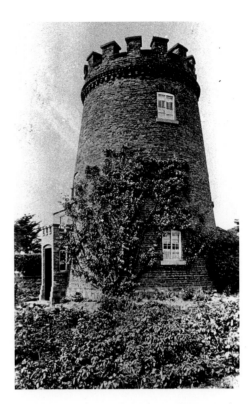

Above left: Keppel's Column, a 115-foot (35 m) tower located on the southern periphery of Wentworth Park, is the tallest of the Wentworth follies; it was originally planned to be even taller and capped with a statue of Admiral Keppel, but evidently the Marquis of Rockingham ran short of funds. It was designed by John Carr and erected in 1778 by the 2nd Marquess of Rockingham to commemorate the acquital of the Admiral Keppel. Keppel was a friend of the Marquis and a fellow Whig who was court-martialled following a naval defeat at the hands of the French in 1777. The column, which has an internal spiral staircase, was open to the public until the 1960s but it is now in a dangerous condition and is kept locked. It is a Grade II listed monument

Above right: The Round House, in Clayfields Lane, Wentworth, has also been known as the 'Saxon Tower.' It had originally been a working windmill and was converted to a dwelling in the early nineteenth century.

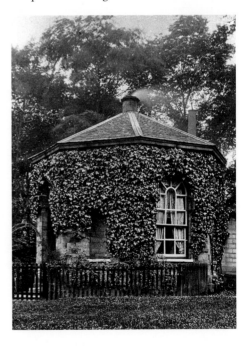

Right: The Mausoleum Lodge, Wentworth Park. On *Britishlistedbuildings*.co.uk it is stated that R. B. Wragg, in 'The Rockingham Mausoleum (1784–93)' mentions: 'the Lodge. *c.* 1790, probably by John Carr of York for the 4th Earl Fitzwilliam'. It is then pointed out that the Lodge guards the entrance to the Rockingham Mausoleum and that 'this building in appearance is more of the Flitcroft period'.

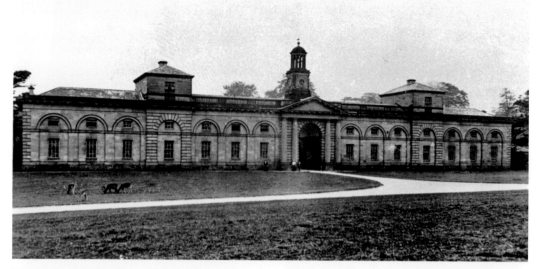

The Wentworth Woodhouse Stable Block is Palladian in style and dates from 1768, being the work of John Carr. At one time it could accommodate eighty-four horses. Pevsner mentions that the stables comprise fifteen bays with a rusticated entrance with Tuscan columns, pediment and cupola.

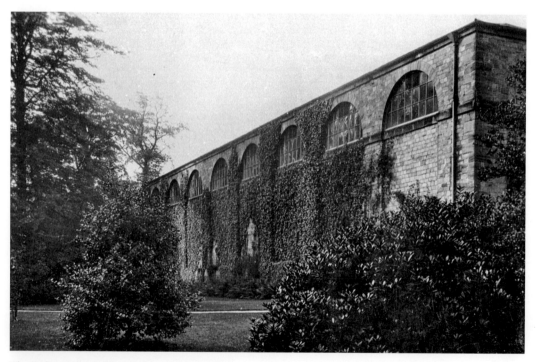

The Riding School, Wentworth.

Wentworth's old church was originally a chapel-of-ease. Large scale alterations and rebuilding took place in 1485 and 1684. In the mid-1920s, the chancel and north chapel were restored by the 7th Earl of Fitzwilliam. The main south porch, the tower and parts of the walls remain. In more recent times, under the ownership of the Redundant Churches Trust, the church was extensively restored. There are some impressive family monuments inside the church, including a floor brass, Elizabethan tomb effigies and wall monuments.

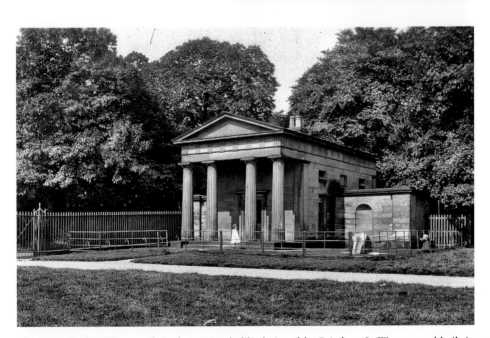

The Doric Lodge, Wentworth Park, was probably designed by Pritchett & Watson, and built in the early nineteenth century. It resembles a Tetra-style Greek Doric Temple.

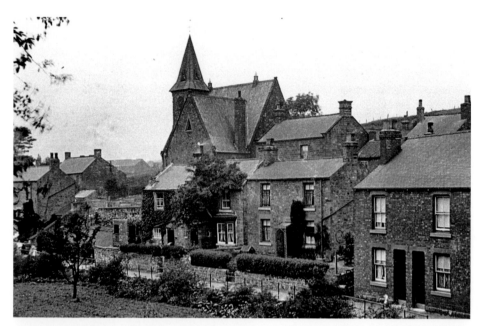

Two views of Whiston, both taken from impressive vantage points, with the Methodist church featuring prominently. It was built in 1866, and replaced an earlier chapel erected in 1822. Prior to this time, the Wesleyans held meetings, between 1771–1822, in Stanley Cottages on Hollowgate. In 1874 the parish clock was placed in the chapel tower, paid for by public subscriptions. Eleanor Kimber in *Youthful Memories*, undated, states 'Sunday at Chapel was a very full day for some of us. An early prayer meeting, asking for a spiritual blessing on the day's service, followed by Sunday School at 9.30 am and the service at 10.00 am. The family from the manor house filled the top pew every Sunday morning, and a full row of well-dressed ladies and gentlemen walked up the street after service – no cars then to obstruct pedestrians as they took a leisurely walk.' The old wooden spire was replaced with the concrete spire in 1949 at a cost of £290. The contractors for the work were Messrs Andrews, Baldwin & Co.

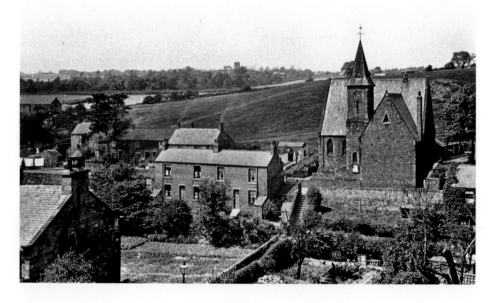

Whiston church and rectory. The *Sheffield Star* of 7 May 1959 said: 'Whiston is a village with a split personality. To the Rotherham side, and on the hills, there are new estates. Below, nestling in a hollow, is one of the best examples of an English village. It consists mainly of old stone cottages, some of them in terraces on the hill, and between which run little paths and steps.' Whiston parish church visitor's guide states that for over 800 years the parish church of St Mary Magdalene has stood above the village. The reason for the church's position above and outside the settlement is unclear. It is tempting to speculate that the village may have originally clustered around the church but later migrated into the valley where water was more readily available. An alternative thesis might be that the church occupied the site of pre-Christian religious significance.

Standing north of the lychgate are the village stocks that, as can be seen, could accommodate three people. One of the stone posts bears the date 1768.

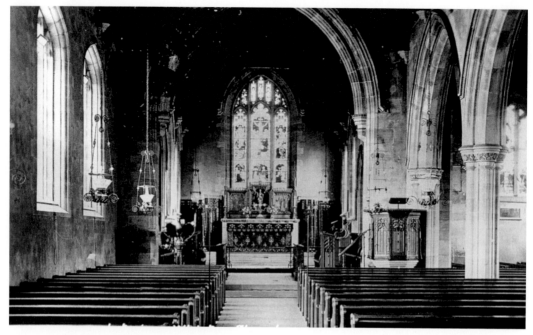

Whiston church of St Mary Magdalene is an edifice in the Norman and late decorative styles. It was restored and partly rebuilt under the direction of Sir Gilbert Scott at a cost of around £8,000, towards which Lady Charlotte Howard (d. 1886) made a donation of £5,000 in memory of her brother the Revd William Howard, rector there in 1841. The interior contains several stained-glass windows, including one dedicated in 1890 to Henry, 2nd Earl of Effingham (d. 5 February 1889) and another one of 1891 commemorating the Deakin family. The register dates from 1594.

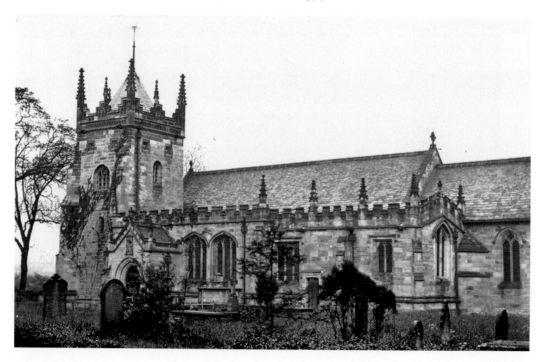

Whiston has been described as a village built on several levels, the main part being like a great cleft in the surrounding countryside, but at both ends it levels out and joins with the surrounding landscape.

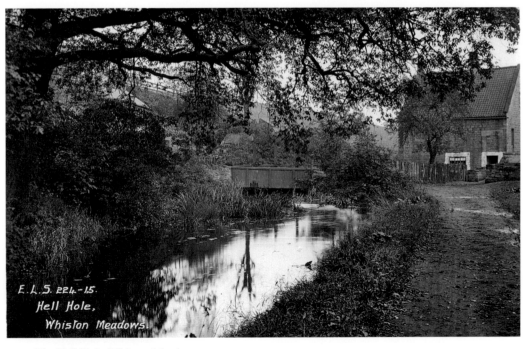

E.L.S. 224-15.
Hell Hole,
Whiston Meadows.

The Hell Hole, Whiston Meadows.

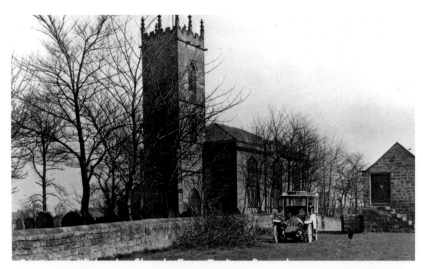

A church at Wickersley was built from a very early period. The latter Early English church was said to have had a chancel with a Lady chapel and one belonging to the Lord of Wyckersley. And, although still in good condition it was taken down, with the exception of the tower, in 1834. The present church of St Albans is a building of stone in the Gothic style, consisting of chancel, erected in 1886 at a cost of about £300, nave and an embattled tower. The reredos was erected in 1890 as a memorial to the late William Aldam, Lord of the Manor, who died in 1890. The register dates from 1540 and a list of rectors extends back to 1240.

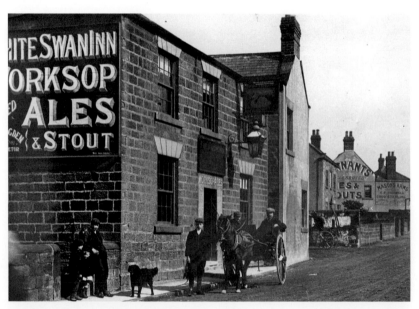

The White Swan Inn, Wickersley, when Fred Longden was the licensee. Also to be seen in the distance is the Masons Arms. William White in 1913 stated that the parish is well-known for quarries of fine soft grit stone of which grit stones were made for the Sheffield grinders. The population in 1911, around the time these Wickersley pictures were taken, was 953.

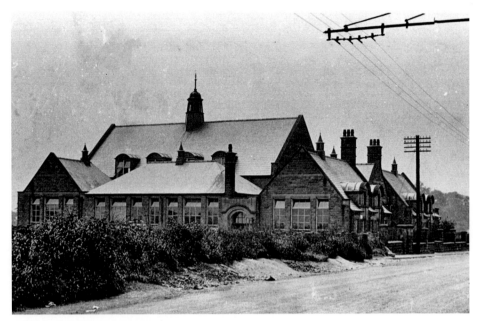

With the growth of population in Wickesley at the turn of the nineteenth century, the church school became overcrowded and in 1909 a temporary tin school was erected on Bawtry Road. The temporary school was replaced by the Bramley and Wickersley Council School in 1911 to serve both the parishes of Bramley and Wickersley. The original Bramley village school stood near the junction of Lidget Lane and Moor Lane South.

A 'receiving house' was opened in Wickersley in 1847–48, receiving letters from and for a mail cart service, operating between Rotherham and Bawtry. In 1860 the 'receiving house' was upgraded to a post office, with Sarah Unwin being appointed the postmistress at £2 a quarter. She also 'doubled' as the letter carrier, delivering mail to Bramley, Flanderwell, Hellaby and Brecks.

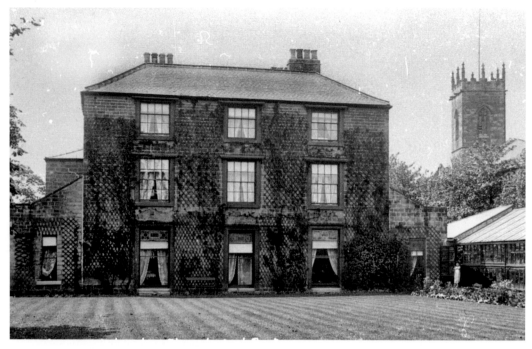

The rectory at Wickersley was demolished in 1955.

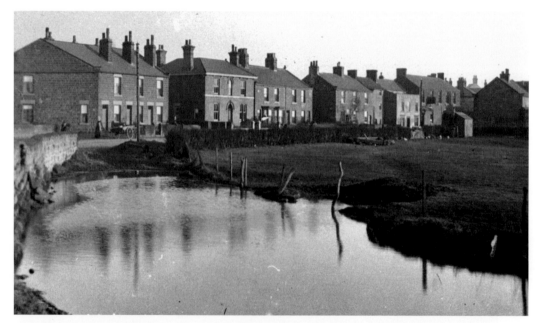

View of Bawtry Road, Wickersley. For most of the area's early history, farming was the dominant influence. But from the early seventeenth century, quarrying was an important village industry, becoming a major employer in the area. There was also a tannery attached to a local farm. In the years following the First World War, the population expanded to over 7,000; the development of Listerdale by Joseph Lister, in the 1930s, adding considerably to this.

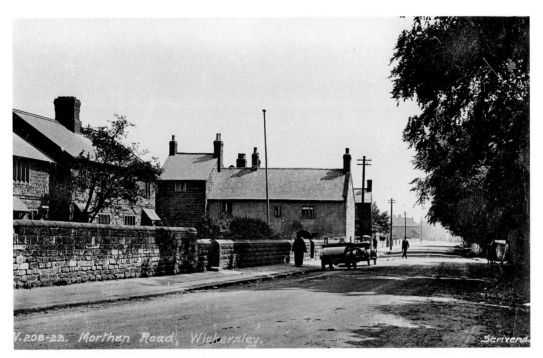

View along Morthen Road, Wickersley.

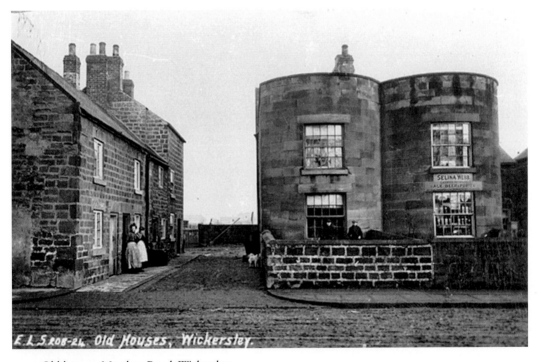

Old houses, Morthen Road, Wickersley.

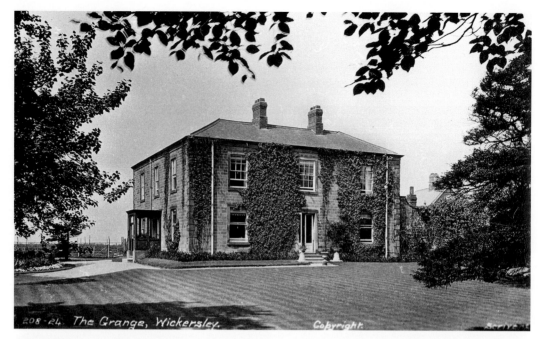

Around 1800 Robert Wylde Moult resided at Wickersley Grange, when it was a one-storeyed building with a thatched roof. Moult left the estate to his nephew, a Mr Aldred, with the proviso that the house should not be altered. In spite of this, the Grange was demolished and rebuilt afterwards in a Georgian style.

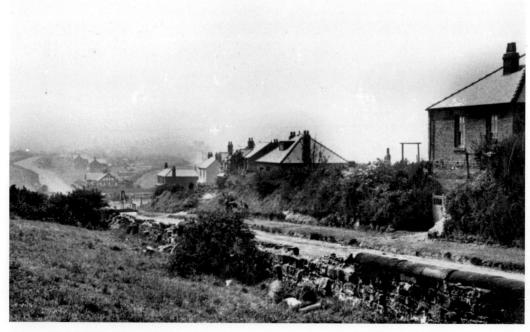

View of Nether Moor, Wickersley.

TWO

Rotherham: The Town

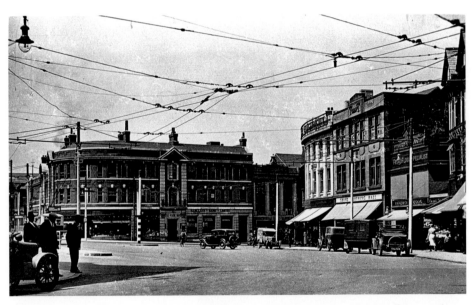

All Saints Square, which during the 1930s became the main town centre terminus for motorbuses and trolleybuses.

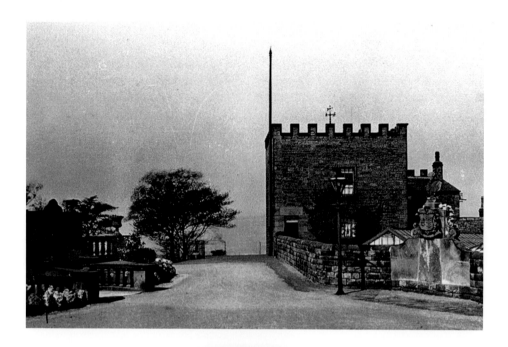

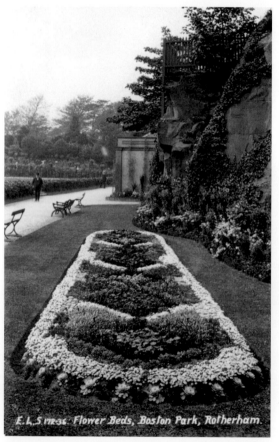

E.L.S 1836. Flower Beds, Boston Park, Rotherham.

Boston Castle, a small square building with battlements, was erected in 1775 by the 4th Earl of Effingham, who supported the American cause in the War of Independence. Until 1872, Boston Wood was just woodland and quarries worked by a Mr Birks. A little later, Rotherham Corporation made an arrangement with the Effinghams to lease the area and convert it to a park. The official opening took place on the centenary of the Declaration of Independence, 4 July 1876. Thereafter thousands of people from all around the district made their way to this 'lung of Rotherham'. It was said that the flower beds were once the envy of the whole of Yorkshire, and many compliments were paid to the park keeper, Henry Albiston, for his floral displays. When the lease expired, the Corporation purchased the park from the Earl of Effingham.

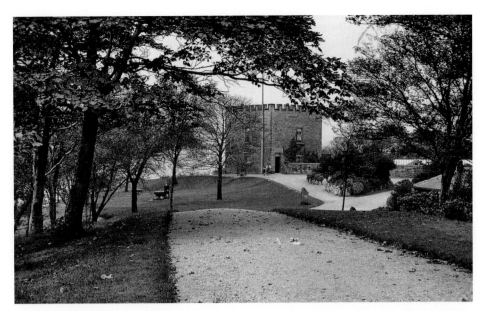

The castle was allegedly built as a shooting lodge/place from which to admire the view from that point. During 1876, it was derisively noted in the *Rotherham Advertiser* as a 'castellated pigeon cote'. Tea drinking was said to have been forbidden at the castle's house warming.

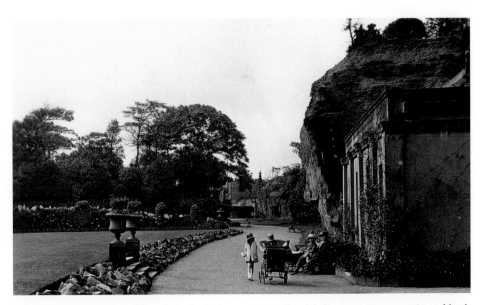

Just after one o'clock, 4 July 1876, the Volunteer Brass Band led a carriage procession of both local and visiting guests through the town to Boston Park where the Mayor and Mayoress of Rotherham were waiting to greet them. A procession made up of guests and members of the Town Council, and led by the band and Ald. Guest as commanding officer, made a circuit of the park. While this was going on, carriages were plying to and from Rotherham bringing crowds of visitors to the Park for the first time. By the time the civic party returned to the castle, a large gathering had formed in a circle in front of the castle. Ald Guest then formally handed over the park and castle to the Mayor and Ald. B. E. C. Chambers 'for the free use of the public'.

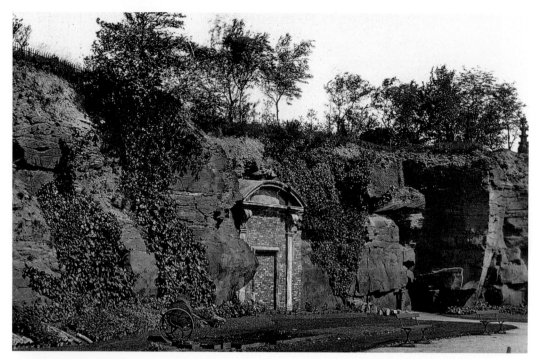

A feature of Boston Park is the doorway from Jesus College, founded by Thomas Rotherham in 1483.

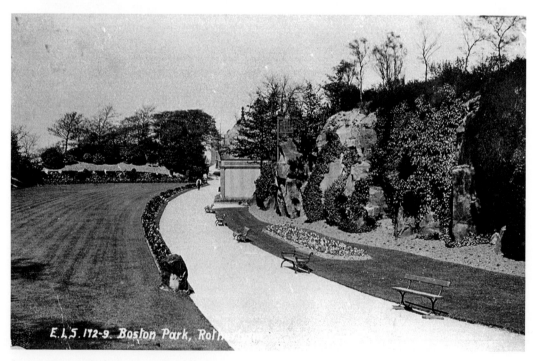

E.L.S. 172-9. Boston Park, Rotherham

Scene in Boston Park, Scrivens obviously finding much to photograph in this locality.

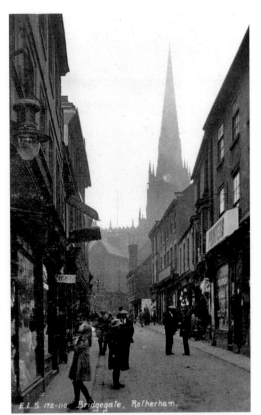

Bridgegate is seen in these two views before the thoroughfare was widened during the 1920s. The (false) half-timbered building on the left (bottom picture), is the Turf Tavern, which took its name in 1870, previously being known, from at least 1822, as the Boot & Shoe. The Turf closed in 1915 and was subsequently demolished in the redevelopment. New premises were later opened in Corporation Street.

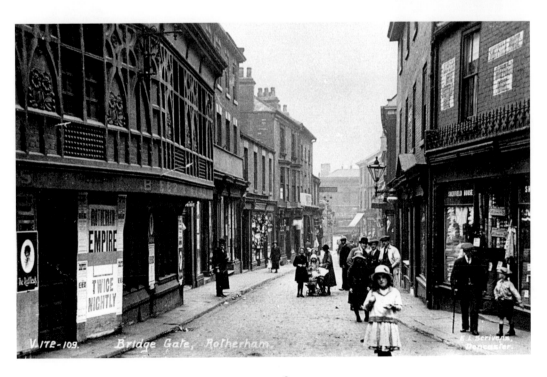

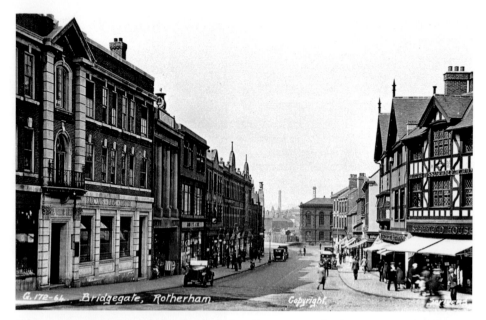

A later view of Bridgegate, facing the gasworks offices, seen in the distance on Frederick Street. Barclays Bank and the White Hart are featured on the left; the Sheffield House is on the right.

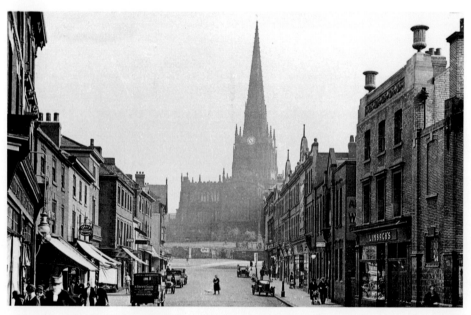

Bridgegate looking towards All Saints church, rising magnificently in the background. A lorry belonging to chemist H. Davy may be seen off-centre to the left. Among the properties on the right are Limbach's and the Angel Hotel. The latter was originally titled The Bull, the name change occurring during the late eighteenth century. The premises were rebuilt in 1915 during the redevelopment of Bridgegate, H. L. Tacon & Son providing the designs. The motor vehicle of photographer Edgar Leonard Scrivens is included in the composition off-centre to the right.

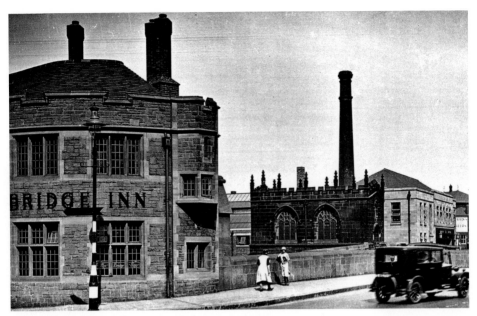

The Bridge Inn, featured in both these pictures, dates from around 1778. The building in the picture below was demolished during the late 1920s, a new pub being built in 1933. The delay in rebuilding was caused by the construction of a new bridge. This was needed because the considerable increase of traffic was too much for the ancient bridge to endure. Temporary strengthening was carried out in the early 1920s, but a new bridge was completed in 1930. Building the new bridge and the preservation of the old one was carried out under the auspices of the former Borough Engineer, Major Vincent Turner. The work on the old bridge was supervised by W. Bond, of HM Office of Works (Ancient Monuments). An opening ceremony was performed on 28 April 1930 by Minister of Transport Herbert Morrison, in the presence of the Mayor (Ald. E. Cruikshanks), members of the Corporation, the Feoffees of the Common Lands and numerous other local dignitaries.

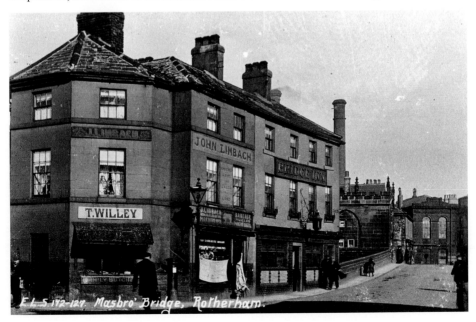

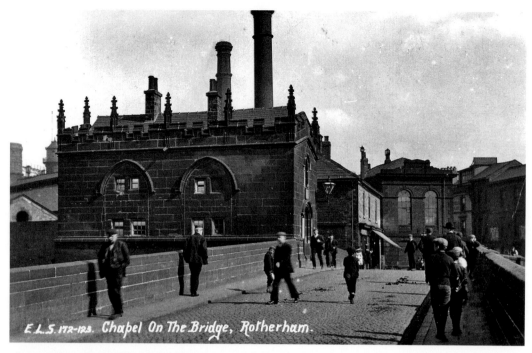

E.L.S. 172-123. Chapel On The Bridge, Rotherham.

The chapel on the bridge, featured in both pictures, dates from around 1483, and part of the cost of construction is believed to have been defrayed by Thomas Rotherham, Archbishop of York. For a period (1779–1826) it was used as a prison, with a cell in the crypt. During its lifespan it has also been used as an alms house, a dwelling, and tobacconist's shop. Since 1924, when it was converted again for religious use, services have been held there.

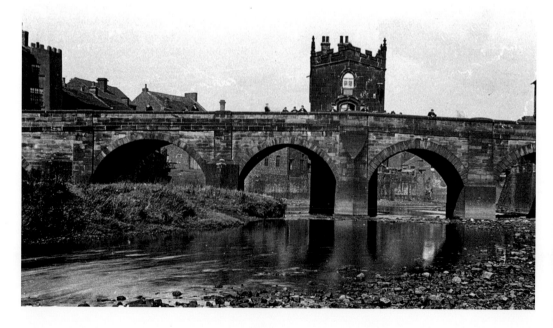

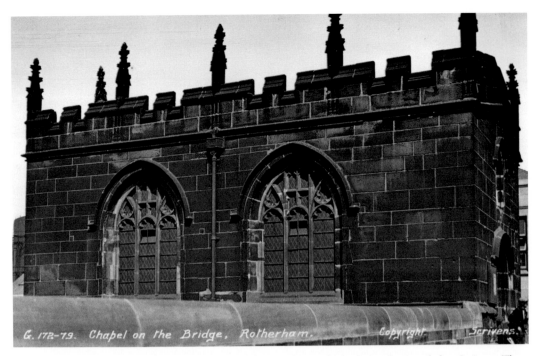

Two close-up views of the chapel on the bridge, a subject which obviously appealed to Scrivens. There are only four surviving bridges or chantry chapels in England, two of which are in Yorkshire, one at Wakefield, the other in Rotherham.

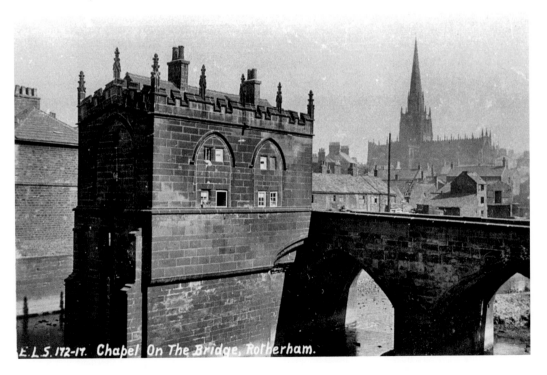

A view along Broom Road.

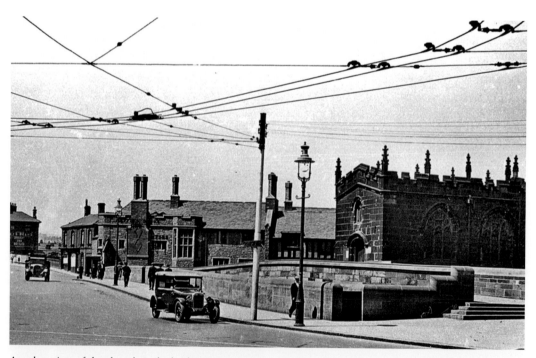

Another view of the chapel on the bridge. At one time it was said that a light was lit in the chapel every night to guide travellers into Rotherham. The chapel might also have been used as a place to house people suspected of having the plague.

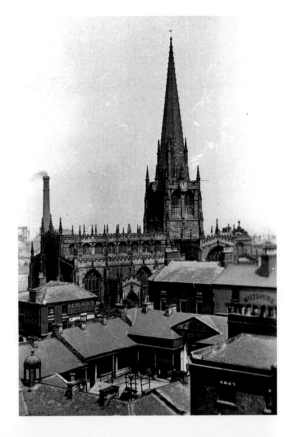

All Saints parish church, also known as Rotherham Minster, is in Church Street and the 180-foot spire is clearly in evidence here. A church had existed on the site from around AD 937. The present church dates from the thirteenth century, though has undergone many changes during the intervening years, not least the restorations of 1873–75. It has been described by Pevsner as 'the best perpendicular church in the country', and by Simon Jenkins in *England's 1000 Best Churches* as 'the best work in the county'. Part of the market can be seen in the foreground.

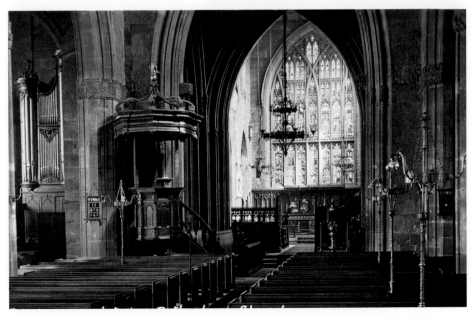

Interior view showing the nave, All Saints church. The nave roof was restored in the early 1990s and the seventy-seven bosses were regilded. Each one is an individual; no two are alike.

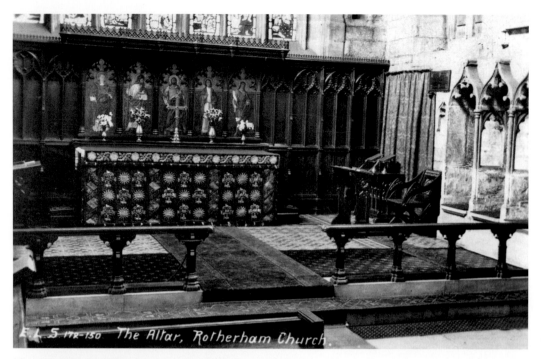

The altar, All Saints church.

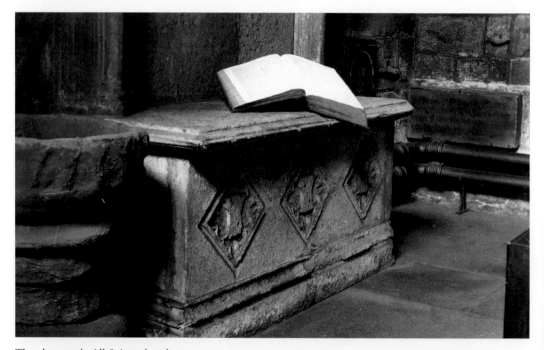

The altar tomb, All Saints church.

The font, All Saints church.

The screen, All Saints church.

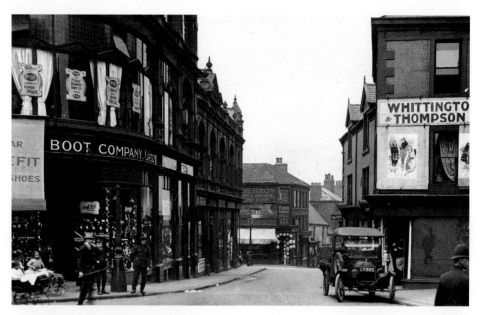

Church Street with Imperial Buildings on the left. This latter structure was erected by Rotherham Corporation in 1906–07 on the site of the old meat shambles. It originally consisted of eighteen shops facing Market Street, High Street and Church Street, with meat shops in the interior and offices on the upper floors.

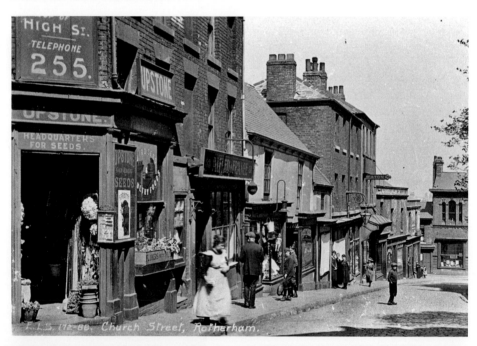

Church Street, where the traders at this time were Albert Upstone, seedsman; Alfred France, butcher; Woodhead Bros, electrical engineers; Henry Gorrill, grocer; John D. Eaton, pawnbroker; Harold Maxfield, toy dealer; and the Singer Sewing Machine Co. Ltd.

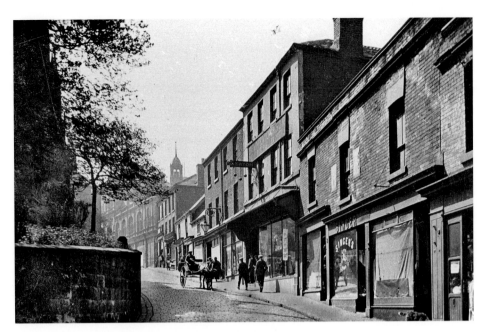

Church Street, showing Imperial Buildings in the distance.

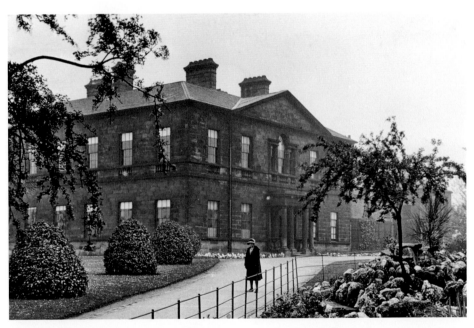

Clifton Park was purchased by Rotherham Corporation in 1891. Following improvements, it was opened to the public by the Prince of Wales (later King Edward VII) and Queen Alexandra on 25 June of that year. Clifton House, built by Joshua Walker (1750–1815) during the 1780s and later occupied by William Owen, was opened as a museum in 1893. Local societies and individuals contributed items to the displays and a Mr Key of the Victoria & Albert Museum superintended the placing of items in the various cases. It was the intention that the museum would become 'a centre of education and recreation combined' for the people of Rotherham.

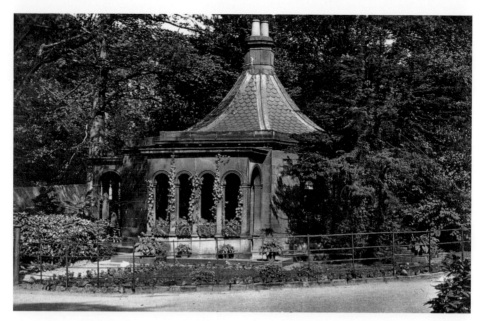

The lodge at the Doncaster Road entrance to the park is thought to have been built in the 1830s. Shown on the 1851 O.S. map as Clifton Lodge, it was known locally as 'Birdcage Lodge', probably because a narrow road opposite was named Birdcage Lane. Before being demolished in 1946, it was used as a house by park keepers and gardeners.

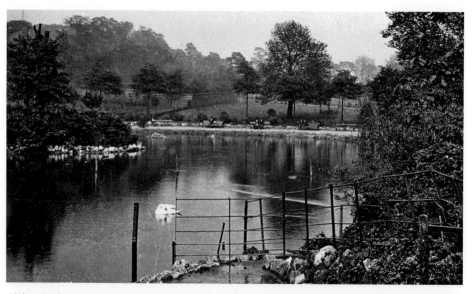

Clifton Park was intended to serve the needs of the growing population settling in the Eastwood area. Initially, £500 was spent on improvements. The opening ceremony was attended by thousands, and was celebrated with fireworks, bands, coconut shies and dancing. The high point of the afternoon was a balloon ascent by Captain Whelan of Huddersfield, which nearly ended in disaster when Councillor Thomas became entangled with the ropes and was almost carried off hanging upside down by the legs. Fortunately, he managed to disentangle himself.

The main entrance to the park at the Clifton Lane/Doncaster Road corner was improved around 1900 with the erection of massive pillars and cast-iron gates. However, the gates were removed during the Second World War and the entrance remodelled in subsequent years.

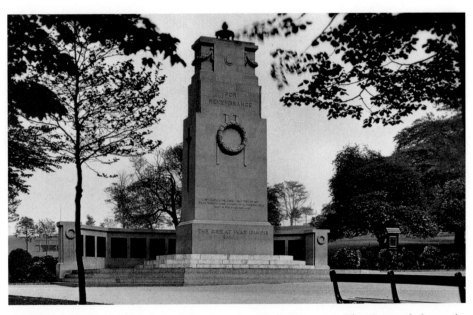

The Clifton Park cenotaph was unveiled on 26 November 1922. The Cenotaph bears the inscriptions: 'The Great War 1914–1918 and The World War 1939–1945. If I should die, think only this of me: That there's some corner of a foreign field. That is for ever England.' Behind the cenotaph is a curtain wall with the names of the Rotherham dead inscribed upon it. A plaque on the wall states: '1914 Sic verescit industria 1918. To commemorate the men of Rotherham Who during the Great War 1914–1918 Gave the most that love can give Life itself. For God For King For Country And freedom of the world.'

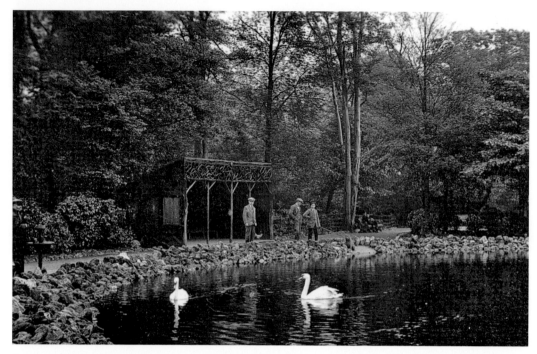

Swans at Clifton Park. In *Clifton House and Park* (rev. 1992) it is said that the 'old fish pond became a popular ornamental lake, with ducks and wild fowl, but was later considered to be insanitary, and was replaced in 1939 by a children's paddling pool'.

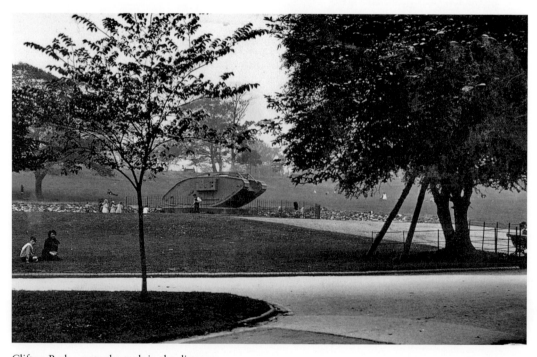

Clifton Park – note the tank in the distance.

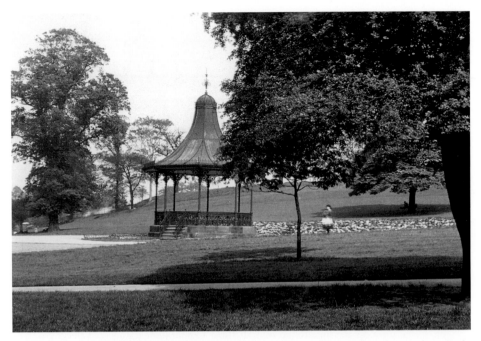

An original cast-iron bandstand survived until 1919, when it was transferred to Ferham Park. The base was occupied by a First World War tank until 1927. A new bandstand was erected in 1928, to be replaced by another, opened by HM Queen Elizabeth II in 1991, to commemorate the park's centenary.

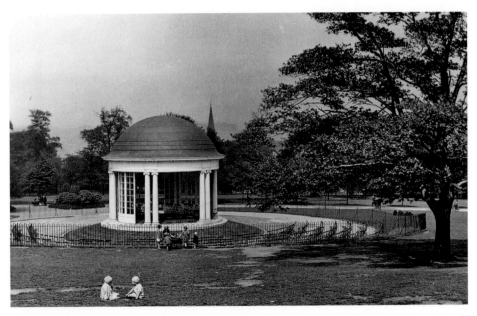

Near the bandstand was a lawn and a picnic area. After the Second World War, brass bands played dance music in the bandstand on Sunday nights. Bands such as the Habershon Brass Band, the Silverwood Colliery Band and the Salvation Army Band gave concerts for charity.

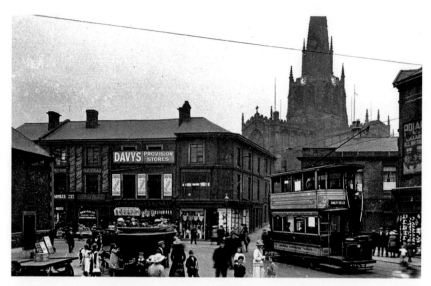

Judging by the number of pictures Scrivens took of the College Square area of Rotherham, he obviously liked this location. Here we see College Square, with College Street or Jesus Gate to the left and Effingham Street to the right. Note the children on a charabanc in the foreground and Sheffield Corporation tramways vehicle No. 72 to the right. Tram services were operated between Sheffield and Rotherham by the Corporations of both these areas. During the mid-1920s, the journey by tram between Rotherham and Sheffield (about six miles) took around thirty-five minutes. The single fare was 4d for an adult and 1½d for a child. The building, just hidden by the tram, was built in 1828 to house the Rotherham dispensary. To the left of this is the route to Church Steps Yard. The photograph was taken from outside the Courthouse.

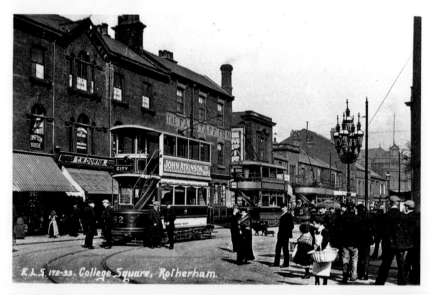

A view of College Square (looking down Effingham Street towards Howard Street) where Sheffield, Rotherham, and Mexborough & Swinton trams can be seen. South Yorkshire's tramway systems were laid to the standard gauge of 4 feet 8½ inches. At one time it was possible to travel by tram from Barnsley via the Dearne Valley, Swinton and Rotherham to Sheffield.

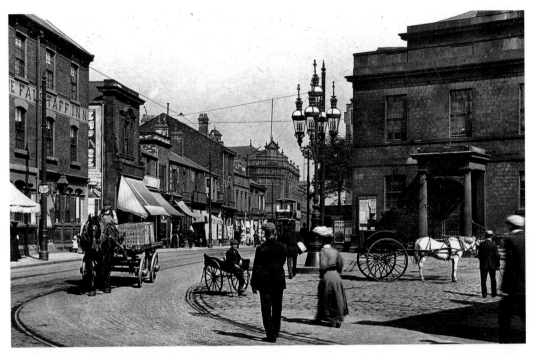

To the left is the Falstaff Inn, dating back to at least 1869, and which closed in 1993, the building becoming a branch of the Bradford & Bingley Building Society.

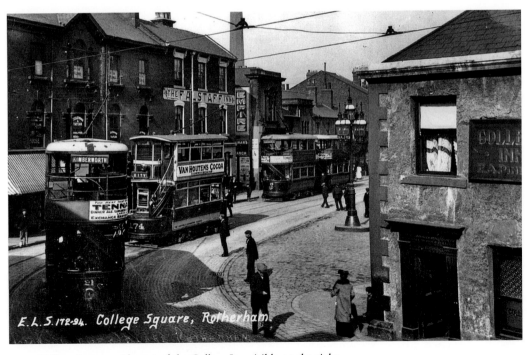

College Square with part of the College Inn visible on the right.

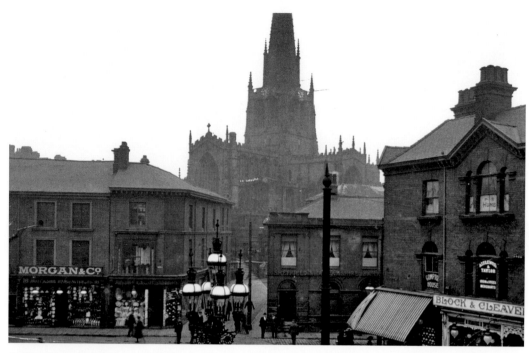

College Square where several business premises are on view including those of Block & Cleaver, butchers (in Compton House); Morgan & Co; and the Sheffield & Hallamshire Bank.

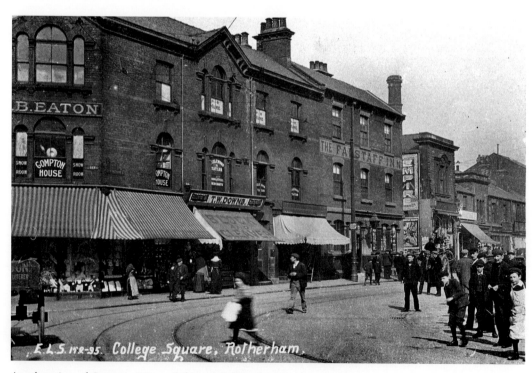

Another view of Compton House (left) and College Square.

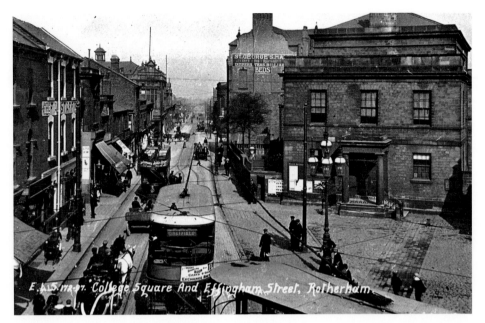

College Square and Effingham Street, with the courthouse (on the right) that was built in 1828 and survived until the early part of the twentieth century. Three Rotherham trams are on view in this picture. Under the Rotherham Corporation Act of 1900, Rotherham obtained powers to operate and maintain tramways. The 'Electric Light and Tramways Committee' was formed, and the powers obtained were implemented immediately. Operations commenced with the opening of two routes on 31 January 1903: College Square to Rawmarsh Road and Fitzwilliam Road. For the first 'official' year of tramcar operation, ending 31 March 1904, an incredible 4,914,479 passengers were carried, and the receipts were £21,341.

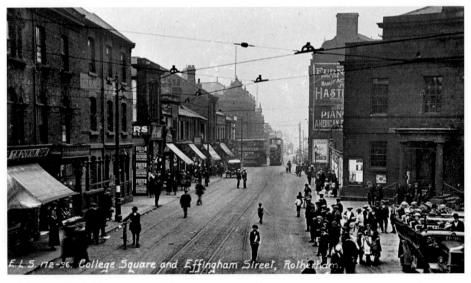

College Square and Effingham Street. Note the charabanc on the right. St George's Hall, built in 1878, is the tall building in the distance on the right.

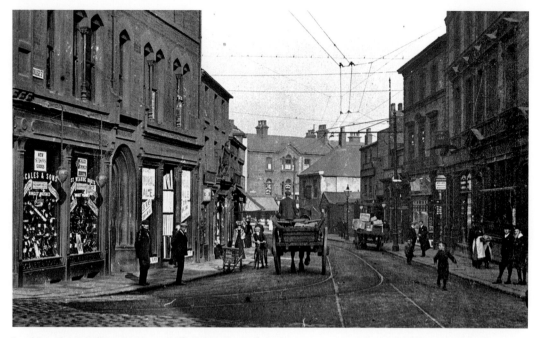

Looking along College Street, to College Square, with Scales & Sons premises on the left. In the distance is the Old College Inn, taking its name from the College of Jesus, founded by Archbishop Rotherham in 1842. Another pub, The Grapes, is on the right.

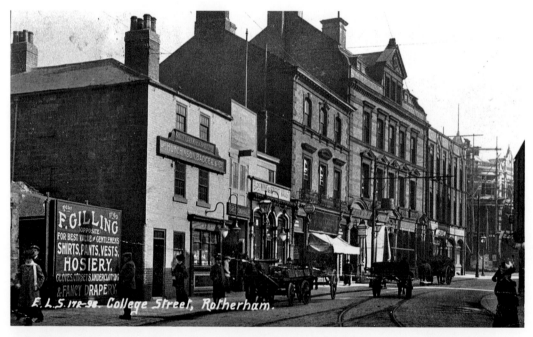

College Street, showing, on the left, the premises of the South Yorkshire Wine & Spirit Co. Ltd, established 1790. At one time the company bottled Bass Ales and Guinness stout, and imported and bonded foreign wines and spirits, as well as being Havana cigar merchants.

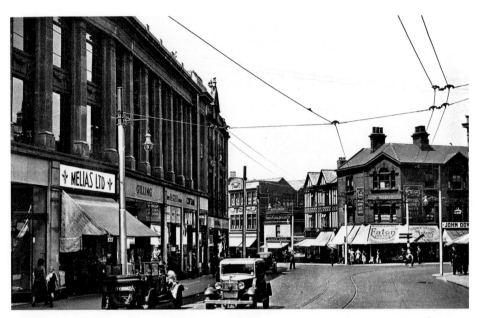

College Street in the days of trolleybus operation. By powers obtained in the Rotherham Corporation Act 1911, Rotherham Transport Department was able to begin operating this type of transport and also motorbuses. By 1931, a start had been made on the conversion from tramcars to trolleybuses. The joint tramcar service operating with Sheffield Corporation continued up to December 1948, when it was changed to motorbus operation. However, trams still operated between Rotherham and the boundary at Templeborough, until it was converted to motorbus operation on 14 November 1949. So ended the tramcar era in Rotherham.

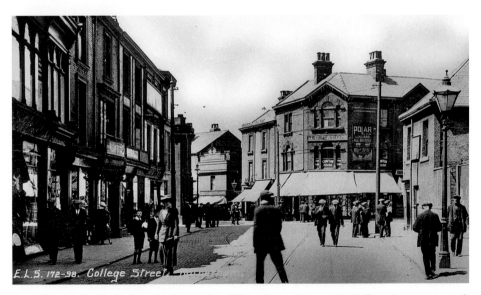

According to the Rotherham by-law and building plans 1897–1948, College Street saw much rebuilding and redevelopment work in the 1920s and 1930s. Plans were submitted by Burtons (1927), the Grand Clothing Hall (1922 and 1926), Marks & Spencers (1932) and Woolworths (1928).

E.L.S. 172-177. Coronation Fountain, Rotherham.

The Coronation Fountain, standing 32 feet high in Effingham Square. Businessman James Hastings offered to finance the project in November 1911. It was unveiled in a ceremony which took place around 1.30 p.m. on 20 June 1912. In 1962, it was moved for the redevelopment of the square. Later on in the decade, and following some restoration, it was replaced near its original site.

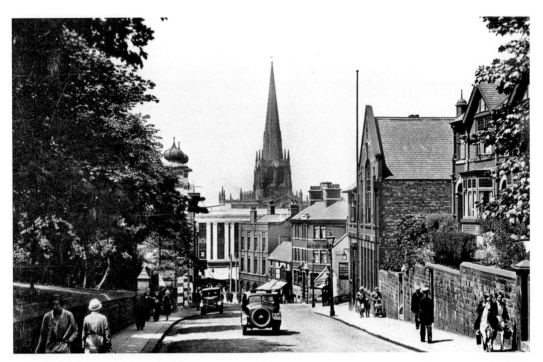

Two views of Doncaster Gate stretching towards the High Street/College Street/Wellgate junction. In the top picture Scales & Sons' premises have been replaced by Montagu Burton's building. The Wheatsheaf public house is off-centre to the right. The pub was rebuilt 1909–10 when Howard Street was widened; closing June 1968. On the left is the Cinema House, the façade having a distinctive appearance. One of the buildings on the right was formerly used by the Conservative Club.

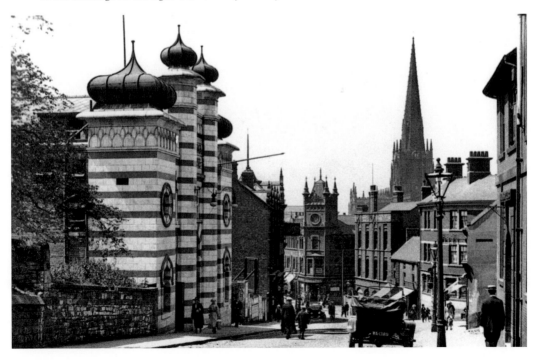

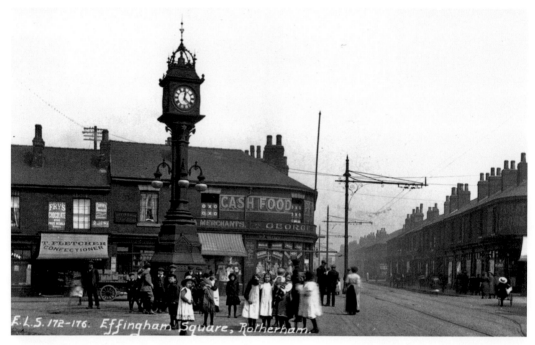

Effingham Square with Frederick Street to the right.

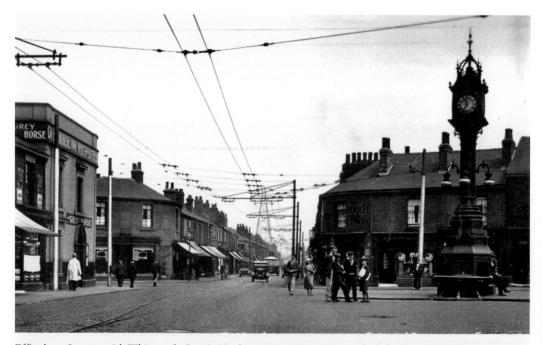

Effingham Square, with Whitworth, Son & Nephew's Grey Horse Inn on the left. The pub had held this name from 1872, previously being known, from 1862, as the Merry Heart. The premises closed on 25 February 1962, the licence transferred to the Tabard, Herringthorpe Valley Road, Herringthorpe.

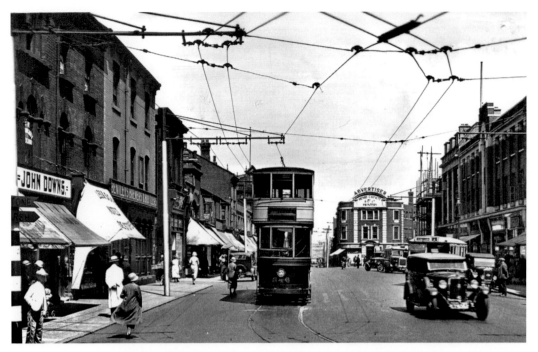

Effingham Street looking in the direction of printer Henry Garnett & Co. whose business premises can be seen in the distance. In March 1929, the tramcar service between Effingham Street and Rotherham Bridge was converted to trolleybus operation and, in conjunction with the Mexborough and Swinton Tramways Co., a through service was introduced between Rotherham and Conisbrough.

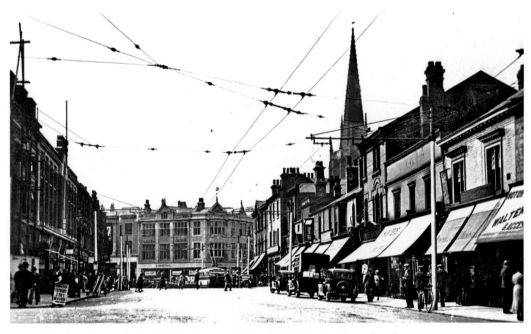

Effingham Street, facing College Street and Davy's Café, in the days after the trams.

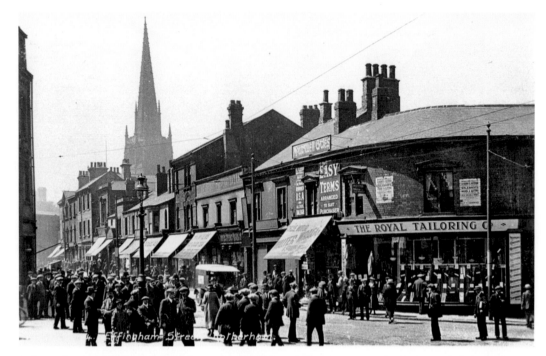

A busy day in Effingham Street, the traders including Walter Wragg, cycle dealer, and the Royal Tailoring Co. The picture was taken near the junction with Howard Street.

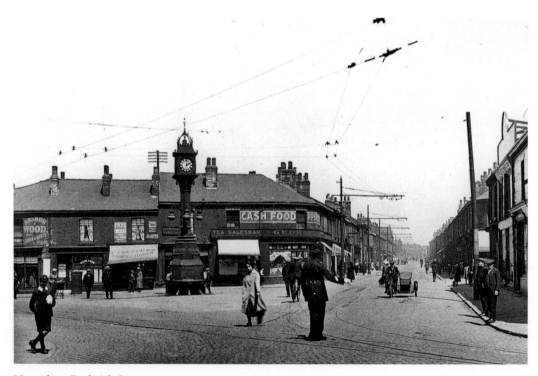

View along Frederick Street.

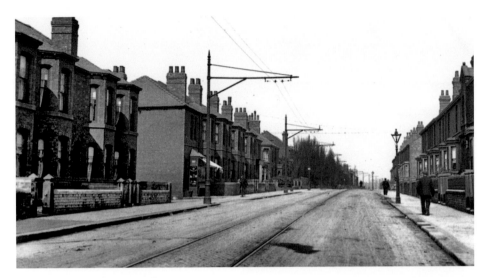

View along Fitzwilliam Road.

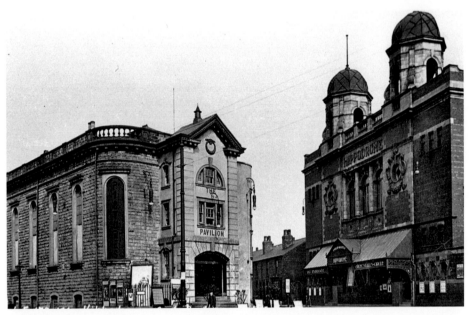

The Hippodrome (right) in Henry Street, built on the lines of the London West End music halls, opened on 3 August 1908. It was designed by Chadwick & Watson of Leeds, with a seating capacity of 2,500. Building work was carried out by J. Parkinson & Sons of Blackpool. The front façade is Italian renaissance in style and the two domes give balance and dignity to the elevation. The interior decorations were Georgian in character. In attendance at the opening performance were the Mayor Dr Lodge, the Town Clerk W. Board, and members of the local Corporation. The theatre closed on 2 July 1932, and was taken over by Rotherham Hippodrome Ltd, opening as a cinema on 17 October 1932. During 1959, the local council revealed it was considering acquiring the cinema site to be incorporated in a new civic centre. The Hippodrome closed on 19 December 1959. The last films to be shown were *When the Devil Drives* and *Runaway Daughters*. The building on the left was formerly a Zion chapel, then became a picture house, the Electra, and later the Pavilion.

The Grammar School's Old Boys' Association was responsible for the War Memorial scheme. The Memorial was unveiled by the Revd Hargreaves Heap on 19 February 1925 after a service in the parish church, with the Archbishop of York preaching the sermon. The Memorial is in the form of a cross, designed from the period of the foundation of the school, the late fifteenth century. In the centre is a carved York rose, and the cross surmounts an octagonal column, standing upon an octagonal base. The names of the fifty-eight old boys and one master who were killed in the war are inscribed on bronze panels.

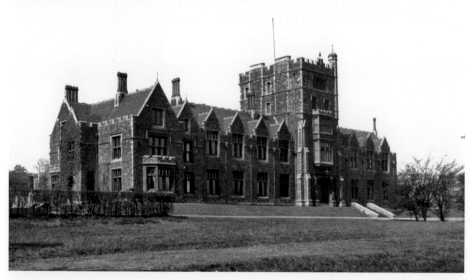

The Grammar School was founded in 1482–83 by Thomas de Rotherham, Archbishop of York, in grateful memory of the benefit he had derived from a teacher of grammar in his native town of Rotherham. The structure depicted here, erected in 1876 at a cost of £26,000, is in the Gothic style, with a central tower 60 feet high. In 1909, a scheme of extension and alteration was completed.

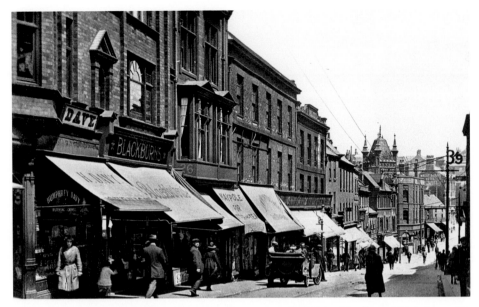

Chemist and druggist Humphrey Davy's premises are on the left in this view of High Street. He also had a business at 19 Bridgegate. He once boasted the 'best stock of nursing requirements, sick room appliances and special medicines'. At one time, the Maypole Dairy Co. Ltd was at No. 24, and grocer John Fawcet occupied Nos 18 and 20.

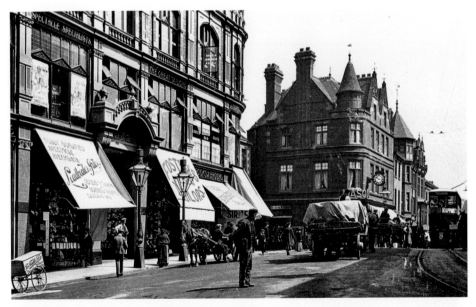

The building just off centre to the right is occupied by the business premises of John Mason. In a *Rotherham and District Annual* it is stated: 'John Mason, jeweller of High Street, Rotherham, who also has a business at Barnsley, was born in 1831, and started in business in the town as a jeweller and clock maker – the traditional occupation of his ancestors for as many generations as can be traced in 1854 opening his present establishment at the top of High Street in 1883 ... He was Mayor in 1888.' Tram No. 25 on the right is making its way to Kimberworth.

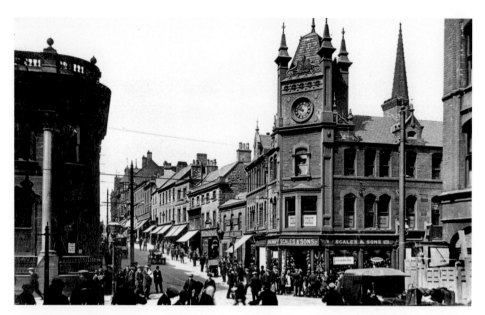

High Street, from Doncaster Gate. The building on the right, occupied by Scales & Salter's boot and shoe warehouse, took on its elaborate appearance in the 1870s, replacing an earlier building. Scales & Salter's eventually became Scales & Son, surviving until the 1920s. Their premises were taken in the redevelopment of the area in the early 1930s, Montague Burton subsequently occupying the site. The bank on the left was built during the early 1890s as a new branch of the Sheffield and Rotherham bank.

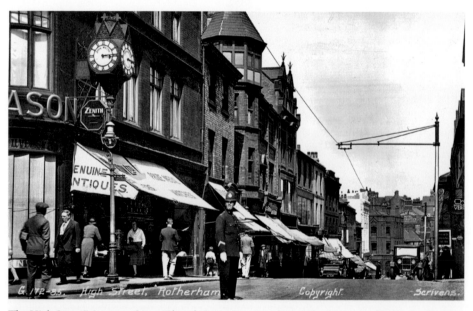

The High Street/Moorgate Street/Church Street junction during the 1930s, traffic having built up to such an extent at this point that it was necessary to have a policeman on duty. In the distance the new building of Montague Burton can be seen.

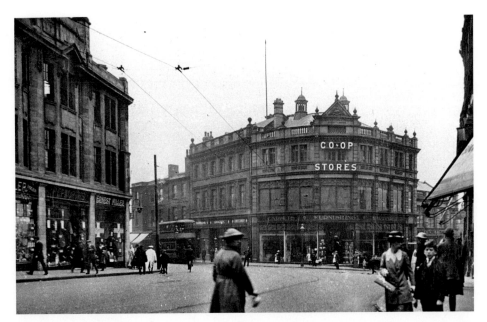

High Street, with Corporation Street to the right and West Gate leading off to the left. The building in the centre belonged to the Masboro Equitable Pioneers Society Ltd.

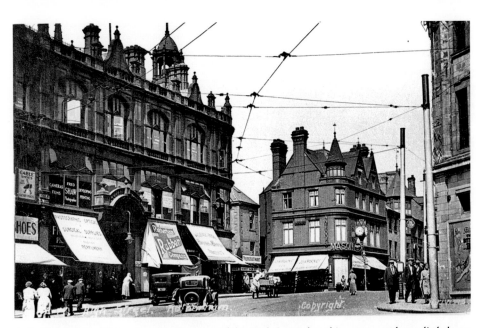

A similar view to that on the previous page of the High Street, but this one was taken a little later; Scrivens having a habit of doing this. George Gummer in *Reminiscences of Rotherham* (1927) states: 'Previous to the erection of Imperial Buildings [on the left] great inconvenience was caused to vehicular and other traffic by the narrowness of that part of High Street. The new buildings were designed by Joseph Platt, the eventual cost of the entire scheme amounting to £19,283. On completion in 1908, the building was officially opened by Charles Stoddart.'

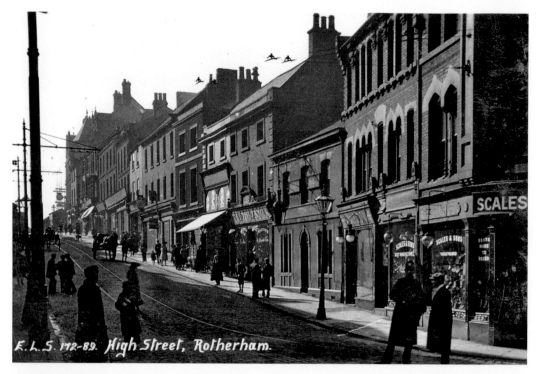

Two photographs of the High Street, one being taken slightly in front of the other. The traders here once included Scales & Son (boot manufacturers); John Cox (tailor); Langton & Son (boot manufacturers) and Boots Ltd (chemists).

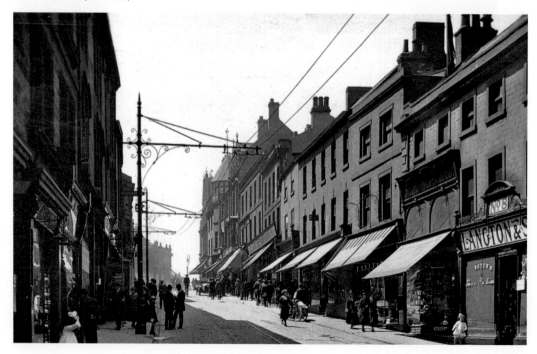

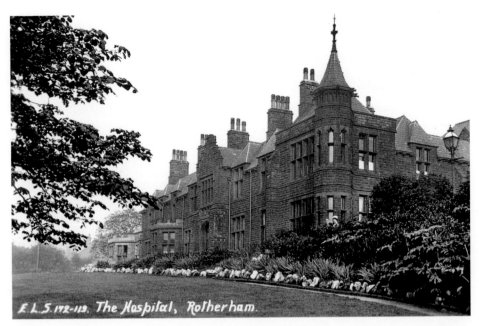

E.L.S. 172-118. The Hospital, Rotherham.

The first stone was laid for the Rotherham hospital and dispensary, standing in its own grounds of four acres in Doncaster Road, in 1870, by the Marquis of Ripon. The building was completed the following year at a cost of £10,000. A mortuary and disinfection ward was subsequently erected at the rear of the premises, at a cost of £300, and a new ward was built in 1886, at a cost of £1,000. A children's ward was added in 1897, costing £800. The women's ward was enlarged in 1903. The old dispensary which opened in 1806, was merged into the new hospital and dispensary in 1872. Two new wards, of twenty-two beds each, were completed in 1925 at a cost, including furniture, of about £14,000. Earl Fitzwilliam was the president, and the Mayor and the Greave of the Feoffes were vice presidents.

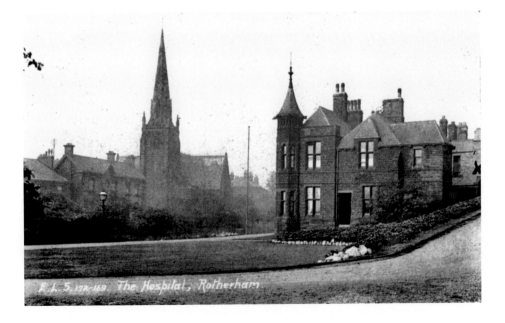

E.L.S. 172-169. The Hospital, Rotherham.

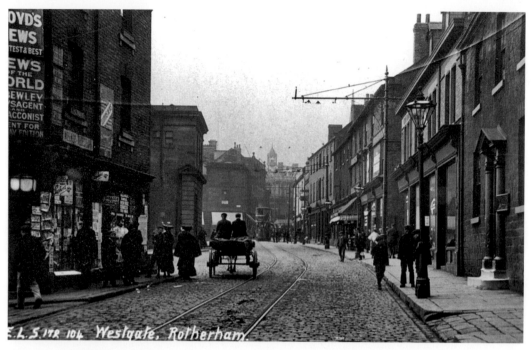

Westgate with Mrs Annie Bewley's newsagent and tobacconist shop on the left.

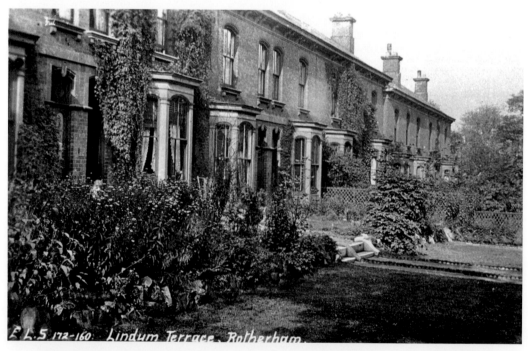

Lindum Terrace, which was built during the 1860s. In a 1912 *Rotherham and Sheffield Trade Directory*, the Lindum Terrace residents at this time included 'a teacher of music, goods agent, bank manager, head mistress, iron merchant and Methodist minister'.

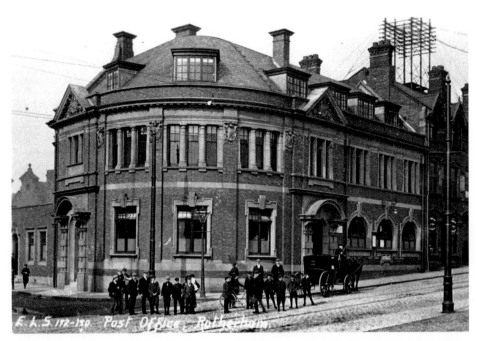

This post office was opened in Main Street in March 1907 by Sir Chas Stoddart. Prior to this the post office had been accommodated in the West Gate Station building since 1880.

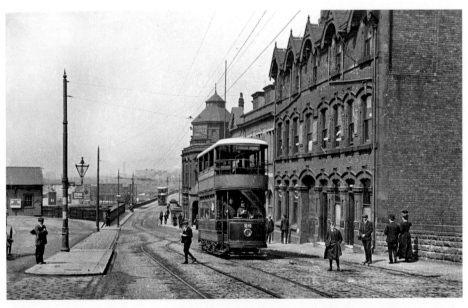

Main Street, looking towards Kimberworth, where car No. 26 is pictured in a track loop. On the right are the public baths, free library, post office and stamp and tax offices. West Gate Station is to the left. The public library was opened in 1887 and destroyed by fire in July 1925. The public baths were also opened in 1887 at a cost of around £8,000, and in 1899 new swimming baths were constructed. Due to fire damage in 1925, the baths were renovated and modernised at a cost of about £7,000.

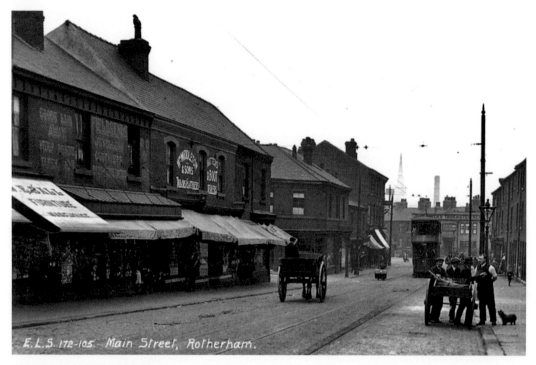

Two views of Masborough Street, not Main Street as titled by Scrivens. Orchard Street can be seen in the distance in the picture below.

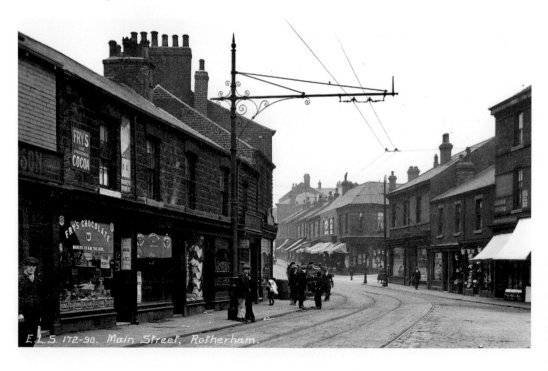

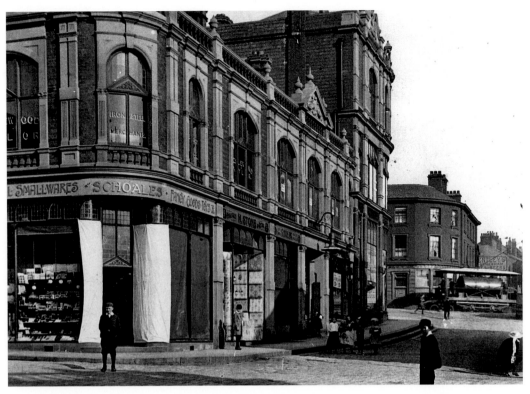

Market Place, with a rare view of the Tramway Department's track cleaner in operation.

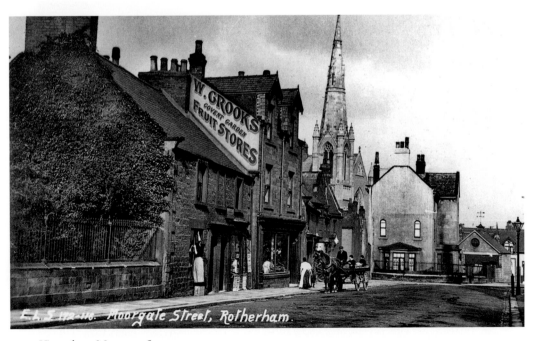

View along Moorgate Street.

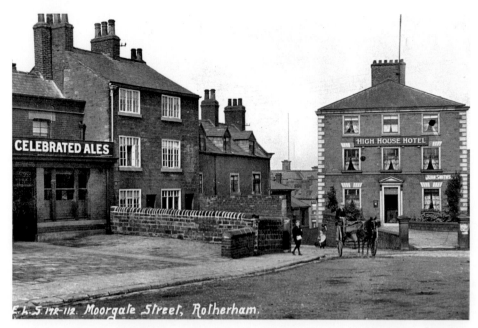

Moorgate, featuring the High House Hotel in the distance, (renamed High Bar in 1984). Paul Satterthwaite in *Rotherham Town Public Houses 1820–1990* mentions that the pub's name could be derived due to its location on fairly high ground at the top of Ship Hill. The Old Cross Keys is on the extreme left. All the property on the left, up to the High House Hotel, has since been demolished.

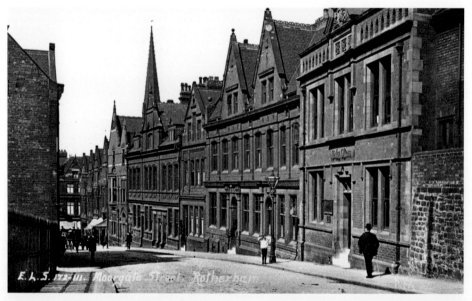

Moorgate, with All Saints church in the distance. The buildings and occupants included Rhodes Parker & Co. Solicitors, at No. 14; the West Riding and Borough Magistrates Clerks Office, at No. 16; the Vestry Offices/Hall, built 1894, at No. 18, and occupied by the County Court Offices, F. Parker Rhodes being the Registrar and High Bailiff.

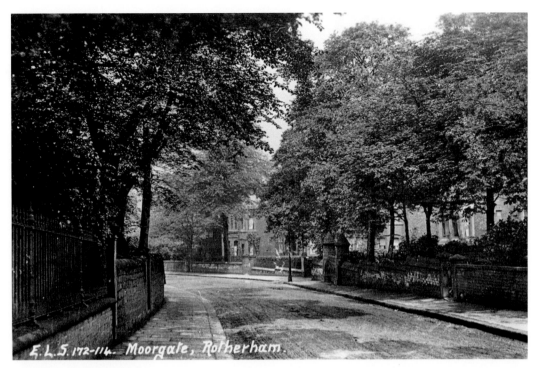

View along Moorgate.

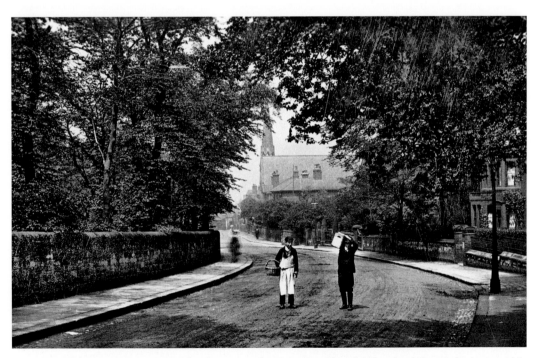

Errand boys in Moorgate. In the distance is the Unitarian Chapel (Church of Our Father), erected in 1879 at a cost of around £3,600. It is a building designed in the Early English style by E. M. Gibbs.

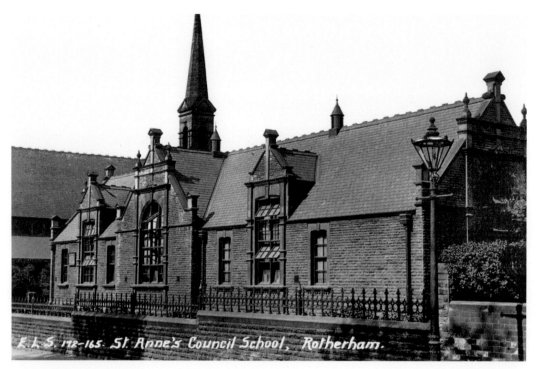

St Anne's Council School.

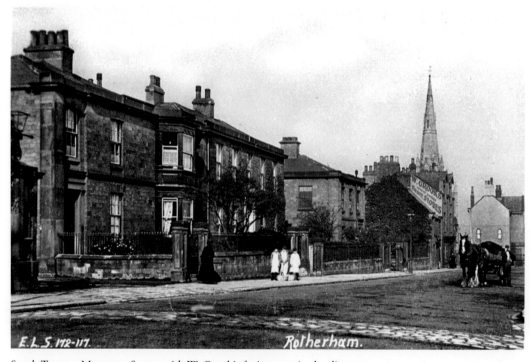

South Terrace, Moorgate Street, with W. Crook's fruit stores in the distance.

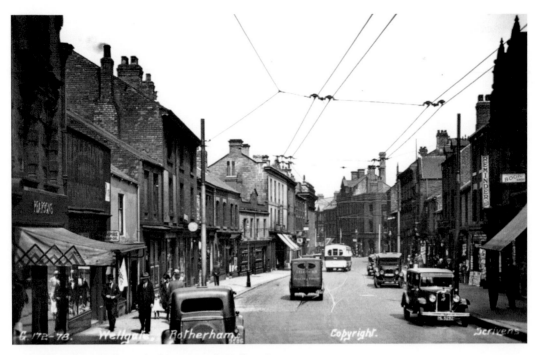

View along Wellgate, looking towards College Street.

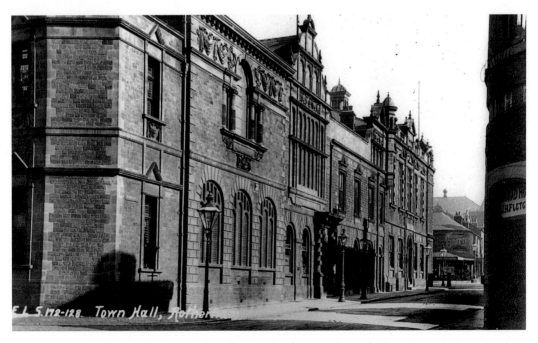

The town hall, situated in Frederick and Howard streets. On the Rotherham Borough Council website the following appears: 'The Old Town Hall was created in the 1980's from the former Town Hall, Assembly Rooms and Police Station; imaginative architecture has enabled most of the original façade to be preserved while opening up the interior as a light and airy shopping arcade.'

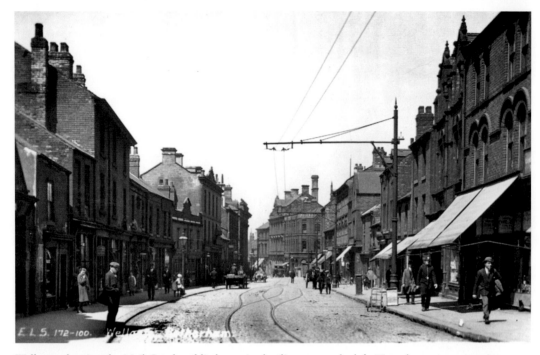

Wellgate, showing the Mail Coach public house in the distance on the left. Note the tramway passing loop in the foreground.